50K a Year from Your Camera

Modern, Effective Marketing Strategies for Your Photography Business

Simple 2-Step Process For Generating 3, 5, or even 10 New Photography Clients Every Single Month With Predictability

By Alan MacLachlan

Copyright and Trademarks

All rights reserved. No part of this book may be reproduced or transferred in any form or by any means without the written permission of the publisher and author. This publication is Copyright 2019 by BLEP Publishing. All products, publications, software and services mentioned in this publication are protected by trademarks.

Disclaimer and Legal Notice

This product is not legal, accounting, financial, business advice and should not be interpreted in that manner. You need to do your own due-diligence to determine if the content of this product is right for you. While we have tried to verify the information in this publication, neither the author, publisher nor the affiliates assume any responsibility for errors, omissions or contrary interpretation of the subject matter herein.

We have no control over the nature, content and availability of the web sites, products or sources listed in this book. The inclusion of any web site links does not necessarily imply a recommendation or endorsement of the views expressed within them. We may receive payment if you order a product or service using a link contained within this book. BLEP Publishing or the author take no responsibility or will not be liable for the websites or content being unavailable or removed.

The advice and strategies contained herein may not be suitable for every individual or business. The author and publisher shall not be liable for any loss incurred as a consequence of the use and or the application, directly or indirectly, of any information presented in this work. This publication is designed to provide information in regard to the subject matter covered.

Neither the author nor the publisher assume any responsibility for any errors or omissions, nor do they represent or warrant that the information, ideas, plans, actions, suggestions, and methods of operation contained herein is in all cases true, accurate, appropriate, or legal. It is the reader's responsibility to consult with his or her own advisor before putting any of the enclosed information, ideas, or practices written in this book into practice.

Contents

50K a Year from Your Camera ... 6
 And it all comes down to your marketing: Here's Why... 10
 Here's the method I use ... 13
 Crushing Results: ... 14
 The Process: ... 15
 What's Happening at the Moment? 16
 End Result: .. 20
How Do You Attract More Customers Than Ever Before? 22
 How do you find your perfect customers, so you don't waste any money? ... 24
 'Multi Touch Marketing'. .. 29
 You only need to focus on 2 things… 30
 What emails do you send? ... 31
 The Result: .. 32
How To Attract Customers In 48Hrs .. 34
 "Here's Why You Get MORE Customers". 35
 Then Magic Starts to Happen… .. 36
 What Most Photographers Do Wrong… 37
 It's the WRONG WAY to Do It – Here's Why 37
 How Do You Solve That? ... 39
 Following Up – Another Great Way to Get Customers 39
 How often do you do it? .. 41
 What should be happening is this… 42
 Another Bonus ... 46
 Use the AOMG Formula .. 47

Because it comes down to this and this is big 48

There are really only 2 numbers that matter: 49

What does this system look like? .. 50

So How Do You Get Customers to Pick You 56

The Difference between a $500 and $5,000 Photographer? 56

Your niche and offer .. 57

This is how you do it now .. 64

Here's the Process from Start to Finish 68

How does it work? .. 69

Make Sure Your Website Is Working for You 74

Want proof? ... 75

That's like doubling your business straight away... 75

When you do this right - you can overcome any competition even if you're more expensive and not yet established 78

Would you like to be using a proven website design? 80

Why it works so well… .. 85

Here's the order you should follow; 85

Guiding your audience: .. 88

Your Offer: ... 89

Don't make these two big mistakes - 92

Special Pages to Attract Even More Customers 94

Follow-Up Marketing .. 104

Here's Your First Customer Follow Up Email 109

Follow This Guide and I Guarantee It Will Get You Leads for Your Photography Business ... 114

Photographers Who Give Away Free Stuff - Get More High Value Bookings and Have an Easier Time Attracting Customers... 126

 From This to This ...> .. 130

 After You've Put Together Your Guide... What Next?.......... 131

 Important... .. 133

A Quick & Easy Guide to Getting Your Photography Business Listed Near the Top of Google So You Attract More Customers Fast .. 135

** FREE BONUS **
Included

EXCLUSIVE: Buy this book and you'll also get **FREE ACCESS** to step by step videos...

You'll see exactly how one photographer booked themselves up for 2 years in advance (They now sell the process to their students for $5k)

You'll see exactly how it was done with FREE watch and copy videos.

(These video's previously sold as part of a $997 training program, and you're getting them FREE with this book)

If you want photography customers – This is the book for you.

50K a Year from Your Camera

50k a year from your camera (profit not revenue).

If you're reading this, I'm sure your first reaction to my title was something like "that's rubbish."

Trust me; I would be sceptical, too. In fact, I'm the ultimate sceptic. I used to think that getting clients online for your photography business repeatedly was a scam or it was only the top pros who could do it.

What I'm about to share with you is my story and some of the results from people who have gone through my training (which I have now condensed down into this book for you).

I created my business starting from home that generated thousands of clients all by using these methods.

Other highly successful photographers are also using these methods right now.

RESULTS:

- One student makes *$14,000 monthly* in her portrait photography business.
- Another makes around *$7,000* a month.
- Another took *$27,000* of bookings with about $700 ad spend.
- Photographers who grew to 6 figures a year in only their second year of business.
- Photographer who generated $31k of sales off just $110 in ads

- Other photographers who have made sales of $8k in 10 days and others doing 5 figure months….

Would you like to know how to bring in new photography customers predictably and repeatably? If so, read on…..

If you've ever thought that you <u>want to increase your bookings</u>, this book is for you.

I'm going to show you a step by step process that you can use to generate yourself new customers repeatably and predictably.

This works for photographers:

- Regardless of who you are,
- Where you live,
- The competition in your area,
- How long you've been established

About Me:

First and foremost, I'm nothing special I pretty much failed at school and my first 'proper' job was in the mailroom of a local radio station. I've got a lovely family and I have a passion and dreams.

I wanted to create a business so I wasn't reliant on someone else to pay my bills AND be able to do the things we wanted to do – holidays, time off with the kids…The extra cash would make that happen.

What got me there was simply taking action - no special gifts or talents – no big investment – just by taking action and doing stuff. Yes, I made some mistakes but in the end - through trial

and error, I discovered how to generate customers online that is both predictable and repeatable and that's what I want to share with you now.

Remember these two quotes...

"A poor photographer who is well-marketed will always outsell a great photographer that is poorly marketed"

and

"Only when your prospects know about you is your skill as a photographer important. Getting prospects to know about you is marketing."

Background:

If you're a photographer right now thinking that the market is too competitive, or everyone is competing on price. I want to tell you **that is not the case**.

In fact, in my opinion there has never been a better time to get clients than there is right now, and I'll show you why in a moment.

Have you ever wondered HOW to bring in new customers consistently?

And then convert them into customers predictably?

Plus, even better to do it in an almost 'hands off' way so you have more free time.

Why? (and the Proof)

To be 100% honest I was sick and tired of seeing everybody else's "systems / programs" that involved so much work and with no guarantee of success. I wanted something guaranteed...

AND...

I certainly didn't want to start blogging and doing 'social media' (I simply don't have time for that) and having to create content all the time.

I just wanted 1 thing that worked and didn't take much time.

AND...

I certainly didn't want to have to do face to face sales.... that's just not me. I'm not a confident 'out-going' person.

AND...

I wanted to make a decent income, to charge the money I knew I was worth. My time is valuable.

More importantly I wanted a way to **get customers repeatedly**.

Sound familiar?

Too many photographers are struggling to get clients when that shouldn't be the case.

How do you get started? Especially in a crowded market or when everyone else just seems to want to work for little or no money?

Perhaps you're not established, how do you overcome that?

I was incredibly frustrated...

My "ah ha" Moment

Having tried many methods, I finally found something that works – my "ah ha" moment.

You need to have that willingness to change and do things a little different.

Once you discover how to gain customers predictably - You'll have a great business.

Because in photography, it's a winner takes all game.

There are no prizes for coming second. You either get the client or don't. If you don't, you're left fighting it out and will probably start lowering prices. You's soon start to think that photography is too competitive. In contrast, the photographer who keeps getting the customers is very happy ☺.

And plus – because they are getting more bookings and making more money, they can get the best equipment and advertise in places you can't. Which in turn gets them even more customers and the process continues repeating itself...

And it all comes down to your marketing: Here's Why...

To be able get a prospect to find you, then convert them into a customer and do it predictably and repeat.

You see this is what most photographers are doing now

Someone comes to your website from Google, Facebook, Yahoo, an ad etc... and you hope they make an enquiry with you. If they do great. If not, you just hope someone else comes along.

Are you using 'Hope Marketing'?

Hope Marketing doesn't work.

Please don't keep 'hoping' for the phone to ring or keep checking emails in the hope of an enquiry...

Photography is a business and you need to treat it as such. You invested in your camera and gear. Now you need an effective way to get customers.

Here's the method I use

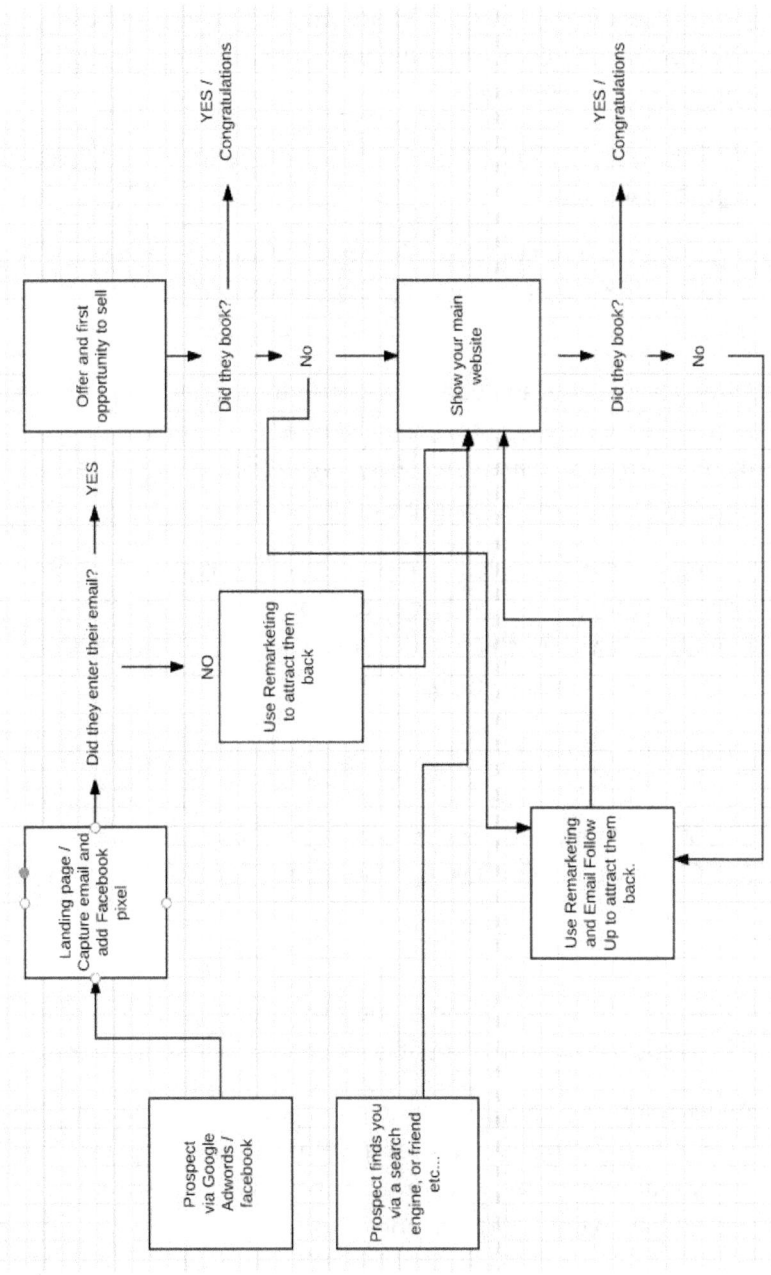

Now you have so **many more opportunities to sell** and make the booking. And if they don't book on the first visit you can now get them to come back and book. Plus, it's *easy to set up and works automatically*.

"Just by following this process most photographers will **increase their bookings**."

Once I discovered how to really attract customers (and you'd probably find the same), you can absolutely dominate the market.

Often you don't even need to be better than your competitors and certainly not cheaper! *"You just need to know how to attract customers and then convert them to customers"*. Once you can do that you can make a great living.

In fact, you almost certainly have the photography skills right now ready to go - you just need to know how to correct your marketing. If you're still reading, then you're about to get the process I recommend you use….

Crushing Results:

$14,000 Monthly in portrait photography – using Facebook
$27,000 in weddings bookings within just a few months from about $700
$7,000 Monthly from home as a photographer

The list could go on – however the aim here is not to boast, but just to show you what is possible when you fix your marketing.

An extreme example (I know) to prove a point – But you don't hear 'Apple' saying we can't sell anymore mobiles because everybody already has one, or we must reduce our prices because everyone else is cheaper.

Or Ferrari saying I think we should sell a 'cheap' car because we are so much more expensive than everyone else and our cars aren't even as practical!

In truth, yes there is a market for 'cheap' photography, but you don't want to be there.

You want to position yourself at the higher end where there is less competition and have people who want to work with you. They see you as the expert.

When you know how to create desire and interest in your photography, and you fix your marketing you really can start to enjoy the freedom and lifestyle that it brings.

The Process:

In the pages below I want to take you through the exact business model that is proven to work and get photography clients.

And show you exactly how to do it, even if you're starting from scratch.

It's called the 'Photography Client System' and you're going to learn 4 critical things in the pages that follow

1 – The single mistake that 90% of photographers are making right now.

2 – How to attract your perfect customer and make them see YOU as the expert.

3 – How to attract MORE customers without more work.

4 – The numbers...

What's Happening at the Moment?

I'm pretty sure this will annoy you – why? Because it's what so many photographers are guilty of...

We all want those lovely high paying clients that we know exist but are so often left with clients who try to knock us down on price or who just want digital images so they can print them themselves and save a few dollars.

Why does it keep happening?

Why are you attracting these 'wrong clients' – Who after all often create more work as well?

Here's what happens...

No matter what level of photographer you are (from those just getting started to the highly experienced full time professional), we all get excited with the fancy new cameras and the latest lenses.

We know we need a great camera (and possibly a backup) and after all it's our job and these are our tools so we want the best we can afford – right? Just like a craftsman wants the finest tools or a mechanic wants quality spanners that last.

They'll help us produce the results we want – and let's face it who doesn't want a new camera. Then of course we spend hours mastering Photoshop and perhaps splash out on accessories like photography bags.... Got to look the part, right? We're professionals after all.

Now you've got all the equipment, you're ready to go right?

Then time passes and it's rather quiet, the customers don't roll in like you hoped and referrals are thin on the ground.

You get a little disappointed, so you read a few blogs, visit some forums, read Facebook posts and you see other photographers are having great success. So why are you struggling? You keep reading…. hoping to find the 'magic answer'.

Then you start reading up on 'marketing' and now know you need a website!

So, many photographers get a 'free' website from Wix (or similar) or perhaps get a friend to do it. You might even do it yourself by grabbing a website template and adding your photos and writing out you on an 'about me' page.

You really don't want to pay too much because you've just spent a fortune on your equipment. After all you only need to show your photos on it…

How hard can it be? – Which by the way is the equivalent of someone saying to you "I'm going to use my Iphone to photograph the wedding – How hard can it be!".

Customers still don't come in the way you hoped – Now what?

Ah, you now discover you need to post stuff to Instagram or Pinterest or write a few blog posts. All of which takes time - time that you don't have (or would rather do other stuff instead). Then these 'good' clients are still thin on the ground.

What's gone wrong?

Why aren't you getting the customers you expected?

You're a good photographer. You've got all the right gear. Your portfolio is up-to-date and looks great.

Finally, you get a customer – Only to hear……

"We only want the digital images because we've over spent on XYZ or we'll just print them ourselves"

Does that sound familiar?

It happens time and time again to photographers. But Why?

I hate to break it to you, but this is the same as when you neglected your marketing.

You bought the cool camera and the gear to go with it. But then when it came to your marketing and website you went with the cheapest / low cost option. Thinking the results would be the same. After all, one website is pretty much the same as another (and yours looks good) so that's not the problem!

Why do you get those customers wanting to knock you down on price? Is it just too competitive now?

Look, I'm sure you're not the cheapest photographer (and if you are – you shouldn't be because that's a fool's game). You want people to pay you for the results you deliver.

However – Failing to invest in your business is a false economy. You need to treat it as a business and be professional. Investing into your marketing is probably the single most important thing you can do.

Without customers you don't have a business – just an expensive hobby.

Your marketing is what gets you customers.

No good being the best photographer if nobody knows about you.

Let's be honest, you know yourself 99% of the time you get what you pay for – Yes you saved yourself a few dollars on web design by using Wix or getting a friend to do it, or some other photography service that had a few 'nice' templates so your website looks good.

However, if it's not getting you clients it's probably costing you much more than you realize. Because around 90% of your clients WILL check you out online FIRST. Your online marketing could be worth 90% of your business

Getting this right can be vital to your success (and profitability).

It's the same with the customers who said to you "We'd really like to work with you, but can you match X because we only can afford Y"

Yet, effectively that was you with your marketing, trying to save a few dollars. These customers are trying to save a few dollars not realizing what it's costing them in terms of quality.

You need to get your customers to focus on the results and the experience you'll deliver. Saving a few dollars on your marketing is a false economy. Just like it is for them.

So how do you overcome this problem? But getting customers to focus on your value.

For example: If you're a wedding photographer and charge $2,500 and a customer contacts you and says "I love your work, but we only have X to spend, can you do it for that?".

Rather than just saying no, you need to turn it around - so they feel it's the wrong decision to go with a cheaper photographer.

You could say - "I'm guessing your wedding is costing X and I know I'm a little outside your budget but in the overall scheme these are the memories you'll be looking back in 5, 10, 15 years' time. You want them to count.

Whether people have 3 or 4 courses at the meal nobody will remember. Your photos are the one thing that you'll always have to remember this day.

You've already said you love my work. I'd strongly suggest you cut your budget elsewhere rather than going for a sub-par photographer and not getting the photos you want".

See how we can turn it around, so it's not focused on price. Suggest if they need to save money, they should take it from another area of the Wedding rather than the Photography budget.

But getting people to contact you and want your service in the first place is your marketing.

In truth, your marketing is what separates you from all the other photographers out there.

You need to be sure you are attracting the right clients.

It's just like if you go to get your car fixed. You really don't care what type of spanner the mechanic uses. It could be the lightest, strongest spanner in the world. But all you care about is the result, you don't mind what tools they use.

It's the same for your customer. They really don't care what type of camera you're using.

They just want great photos of their baby, wedding, son, daughter, pet – whatever it is. What camera you use is not important. Attracting that new customer into your business is what counts.

End Result:

Therefore, you need to improve how you market your photography business. It really can be the difference between huge success and struggling along. Get it right and photography can be very, very profitable for you.

Good news, there is an effective way to put your marketing together so you can get results predictably. Scientists and Psychologists who have studied human behaviour have found (through a lot of testing) what makes us more likely to act in a particular way.

We can take this method and apply it to our marketing. When we present our future clients with the right information in the right order, they are far more likely to buy (and book us up).

This is how you can get a 400% increase in bookings (and sometimes more) which in turn helps to make you more successful (and profitable).

And it all comes down to fixing your marketing... when you do that you can afford the latest cameras, lenses, even nice holiday – Because you have the customers coming in to support that.

It's really not a simple case of showing a 'few nice photos' with a nice website design because that's what everyone else does and it's not that effective.

In fact, there is a solid (tried and tested) method for putting all of this together.

How Do You Attract More Customers Than Ever Before?

In short, we're going to use 'Multi Touch Marketing' – That probably doesn't mean anything to you right now. But it's a game changer for photographers and right now almost no photographers know how to use it fully.

The game is changing... And this time it's a big one.

Forget about the old methods of leaflets, wedding fairs, baby shows, local fairs, networking, blogging, posting on social media – They all take time and money (and aren't necessarily even that effective).

There's an entirely new (and more effective) strategy for marketing to your customers: It's called Multi-Touchpoint Marketing, and it's a game changer.

Plus, it gets even better for you – because from the photographers I've seen only about 1% are currently using this method which gives you a huge opportunity – especially if you get started now.

Until recently you could never have targeted customers as accurately as you can right now. That's why I keep saying ….

"There has never been a better time to be a photographer than there is right now".

However, that is ONLY true for those who know how to market themselves effectively. Other photographers are left struggling...

Right now, you have so many amazing opportunities of how to get customers you shouldn't be relying on 'Hope marketing'.

Don't keep 'hoping' for the phone to ring or for you to get an enquiry email. Help make your photography business a success and put this system into place. Using multi touch marketing and you can start generating yourself a predictable flow of new clients.

It's the most effective form of client generation there is today.

Most photographers simply don't understand how to do this which is why I've created this guide for you today. Put it into place and it will help increase the number of customers you get.

Because in every case I've seen it works and gets you more customers. It's so important you start to use this process now.

Before I go any further, I want you to understand this is a business and you need to invest into it - and then you will see long term and predictable profits. You've got your camera and your lenses but without a way to get customers you've just got yourself a hobby!

Please take this seriously and it can change your life.

Most photographers ignore their marketing. Yet by getting the marketing right, you will have the ability to get all the cameras and lenses you could ever want (and lots more besides ...).

Imagine customers coming to you so you're not left competing on price... you can charge the prices you want and deserve.

To be able to do that you need to attract the 'right customers' first and you don't want to leave that to chance.

How do you find your perfect customers, so you don't waste any money?

By the way you can start this with about $10 or $20 dollars

Update: One photographer I know used this method to get $38.57 back for every $1 he invested. How often did he do it? He took about $27,000 of bookings within a few months and booked himself solid.

This method works and you need to use it.

Step 1 -

You want to find your 'perfect prospect' - your ideal customer.

How do you do that? You want to use the #1 marketing method and allow Facebook to find these customers for you.

*If you already have customers you can ask Facebook to find more customers for you simply by giving them your customer list.

Facebook have so much data they can find customers in your area who are like your current customers and show them your ad.

Results? I use this method myself and it's my cheapest way of getting customers. It's just fantastic.

Please watch the FREE training videos (links at the back of the book).

However, let's say you're just starting out, or you don't have a customer list, or you want to reach a wider audience.

How do you get those all-important new customers coming into your business?

Let Facebook find them for you!

Note: Even If you've tried Facebook marketing before, please make sure you read this full guide as it's so much more effective now and the results can be incredible when you know how to do it correctly.

So many photographers try and then give up when they don't get results straight away (which is great for you). It's important to remember most people don't book photographers on their first visit.

So, when you don't get a booking straight away from your ad a lot of photographers give up claiming it doesn't work.

But that's where 'Multi Touch Marketing' comes in... because this DOES work.

Because when you get this right, often you don't have to do any other marketing (and it saves you so much time). Plus, it's more effective than anything else I know.

First you need to get your targeting right – By that I mean choosing your correct audience. Just the people who you want to see your ad.

For example

1) If you're a Wedding Photographer, you can select people who are engaged in just your area. And if you know it's 90% females who make the appointments you can show your ads just to them.
2) If you do 'Newborns' you can find all the parents who have a '0-1-year-old baby' (or those people expecting a baby if you also do maternity photography).

3) Photograph Pets? You can show your ad to all the pet owners in your area.
4) Photograph food? You can choose restaurant owners.
5) Real estate? You can target real estate agents or hotel owners.

I'd honestly be surprised if there wasn't a way to target just the perfect customer for you.

Step 2 -

Now, Here's the BIGGEST Tip – On your website you want to install the 'Facebook Pixel' because it allows you to do all types of highly effective and successful marketing.

Plus, the good news for you is very few photographers even know about this tactic, let alone use it. And that's crazy because it's one of my most profitable ways of getting customers.

The Facebook pixel is just a tiny piece of code you add to your website. Honestly it takes about 5 minutes to do if you're following my video on how to do it. However, it's super powerful and a crucial step to your 'multi touch' success.

You'll see just how effective (and important) it is shortly.

Step 3 -

Now you've found your perfect audience you want to start the process of converting these people into customers.

The second most important thing (after adding the Facebook pixel) is getting their email address. I have a great 'How To' section which you can get FREE in my training.

It's so important you get the prospects email address as again it all becomes part of this 'multi touch photography marketing' process that can transform your photography business. This is what starts to produce these awesome results you hear about.

It's how some photographers are using it to generate themselves six figure incomes and others into the high five figures.

Marketing has changed and those photographers who understand this process (and more importantly apply it) can be very, very successful.

It's often reported that prospects need 7 points of contact with you before they'll purchase or book you up.

That means your potential customer needs to 'see / hear about you' approximately 7 times before they decide that you are the photographer for them.

How do you achieve that? Well;

Photographers using 'Hope Marketing' (Hoping the phone will ring or hoping to get a booking email), normally struggle along because they have no process in place to get these 7 points of contact. They are just left hoping they get lucky. After all some customers will book you up straight away – you never know you might get lucky!

However, that is very rare and if you rely on 'Hope Marketing' you are leaving a ton of money on the table. While the photographers using this process are collecting clients who buy on the first visit, their second visit, or third visit... and all later points of contact (including more than 7 visits – 7 just happens to be average).

So how do you get these 7 points of contact?

It sounds simple, however it ALL relies on just 2 things

*Please don't overlook this because it seems 'too easy'. So many photographers overlook this step expecting some 'magic

tip' that will transform their business. In truth, the photographers who are successful can rely on just this method.

It even saves them time because they're not busy trying to do all the other stuff 'that might just work' or looking for that 'magic bullet'. They simply focus on two things:

1 – Facebook Pixel
2 – Email

Together, and used correctly, they are very, very powerful and can make you stand out from all the other photographers, especially those relying on 'hope marketing'.

When you start to appear in front of your prospects more often, they start to see you as the authority and the expert in your field. You start to stand out and become the 'go to' photographer, the leader in your market.

And it all happens because you stayed in the front of your prospects mind.

Here's what normally happens to someone who is looking for a photographer…

1 – They'll go online and search for whatever they need e.g. 'New-born Photographer' or 'Commercial photographer' etc…

2 – They'll visit a few photographers, get distracted and carry on later…

Now imagine if one of these photographers who they visited started appearing in front of them, providing them with useful advice, showing them some of great photos they'd taken.

Subconsciously and automatically - that prospect starts to see you as the photography expert, the 'go to' person and generally the person they want to work with.

And that's what you want – the customer to see you as the expert, someone they want to work with. Because when that happens, you become 'desired' - you're not left competing on price. It's how you break away from that low value work and get the clients you want.

Apple are 'desired' and even though they are more expensive and there are lots of other Smartphones, people are prepared to pay more because they see Apple as giving them the best experience. And that's what you want - and luckily for you, you can achieve this using multi touch marketing.

You want to get prospects to see you as the expert, someone who will give them the best result. And yet it comes down to 1 simple technique -

'Multi Touch Marketing'.

The ability to stay in front of your customer as they decide who to book. Your ability to do this can transform your photography business (and income) literally overnight.

Seriously, stop looking for the 'magic bullet' and do something that works and that so few photographers use. You can start to use this process within 2 – 3 hours and enjoy how it improves your photography business and allows you to get more customers.

Not only that, you'll have a predictable and repeatable method for getting yourself customers. It saves you time, allows you to get more customers and do it without competing on price. How good is that?

How Do You Use Multi Touch Marketing in Your Photography Business?

The good news, to make it easy for you,

You only need to focus on 2 things...

1 – That little 'Facebook Pixel' you added. This allows you to easily 're-target' people who have visited your photography site. That means you can appear back in your prospects Facebook feed.

2 – Using Email. You can send your prospects emails and stay in front of their minds. However, there is a right and a wrong way to do this... do it right and it can be your most effective (and profitable way) of getting customers.

Using these 2 methods together you can easily reach that all important '7 points of Contact'.

Massively increasing your chances of getting the customer. Making you stand out.

You can easily appear in your prospects Facebook feed 3 or 4 times. Follow that up with a few useful emails and the number of enquiries you get should multiply.

If you're established, you could see a 400%+ increase in business. If you're just starting out, it can allow you to reach high 4 or even 5 figures per month.

It's the method successful photographers are using right now to generate themselves customers and you too can copy it.

Firstly, I highly recommend you use Active Campaign for your emails.

Active Campaign allows you to send different emails based on what your customers do.

For example, it's no good asking a prospect to book you up if they haven't opened / read your previous email.

With Active Campaign, you can separate everyone out, including people who haven't opened emails, those who have clicked on a link etc...

What emails do you send?

You need to make them useful. You want to send an email that you would want to read. We've all seen those hyped up emails, they're no good to anyone. You want to position yourself as a knowledge / helpful expert. Provide useful advice, something of value...

For example: If you're photographing families you can send an email explaining what to wear so they get the best results from their session. You may think that's obvious but very few photographers cover this and it's a question your customers will have.

Put together 3 or 4 emails that help and provide valuable information to your prospect. That way your prospect is much more likely to read and engage with you. All the while, all the other photographers are simply 'left hoping' that a prospect might just contact them.

Additionally, you should also include links to your website. This is so the prospect can come back to you and re-engage with you and view your portfolio etc...

What do you put on your Facebook Ads for this specific audience? These are people who have already seen your website.

To be honest it can almost mirror what you put in your emails. You can use them both together to make the message more powerful.

So, if you're photographing families one of your re-targeted ads could be 'Here's What You Should Wear for The Perfect Family Photo Session'.

You then take them to a page on your site where you can show them what to wear for the best results. That way you're providing useful content to your audience and again positioning yourself as that helpful expert.

Then when your prospect is on that page, make sure you include one or two testimonials and a 'call to action' (normally a button to book you up or schedule a consultation).

The Result:

Using 'Multi Touch' Marketing, you massively increase your chances of getting a photography booking (some by 400%+) and you can do it without competing on price.

Yes, it takes 2 – 3 hours to set up, but long term it can save you hours and hours of work every month. Because once it's set up, most of it is automated and the results you can achieve are awesome. Now you can get yourself clients predictably and repeatedly because you have a method that works.

This process positions you as the expert in your marketplace almost regardless of your experience. It allows newbies to get a regular flow of customers and experts can massively increase their bookings. It's the most efficient form of Photography Marketing.

You can struggle using 'Hope Marketing' if you want to. You can keep searching for the 'Magic Bullet' if you want to – However those successful photographers who are using this Multi Touch Method can generate themselves 6 figure incomes.

It is what successful photographers use and I highly suggest you start using it too.

How To Attract Customers In 48Hrs

"I want to show you how important it is that you're able to pay money to acquire customers".

It sounds scary I know, but it really isn't when you can copy something that is already working for others.

It's how the 6 figure photographers get so many bookings and keep on doing it.

Then everything else just becomes so much easier.

You won't be struggling for clients. In fact, when you can pay money to get customers that's when you can raise your prices because you start to become 'in demand' –

Let me explain…

Now it's a hard concept for many photographers to understand, because they are simply trying to get clients, it doesn't matter who.

Why Should You Care?

Because when you can pay money to get a customer, you can start to enjoy the freedom and lifestyle that photography can bring you.

Why / How?

Because you're not worried where your next customer is coming from. You have a predictable and best of all repeatable way that generates you customers on demand.

You also don't have to worry about being ranked in the search engines, blogging, Pinterest, Twitter, Instagram etc... It saves you so much time and effort.

In fact,

One photographer I worked with made $38 for every $1 he spent on ads. That's the power of this when you do it correctly. And that's what I want to show you.

He made about over $27,000 from just $700 in ad spend!

(And you don't even need to start that high - simply start with $10 a day and see the results that this gets you).

"Here's Why You Get MORE Customers".

You're no longer worried about appearing 'somewhere' in Google, 'hoping' that a user will scroll down or even venture onto page 2 just to find you. Most searchers will NEVER see your listing! So, you NEVER even get the opportunity to make the sale ...

However, you can automatically appear right at the top = #1

Plus if you want to appear top for 'Wedding Photography' and 'Wedding Photographer in Las Vegas' and in fact any phrase or words you want – you can!

When you're at the top, not only do you get more visitors you also get the **first opportunity to get the customer** (and not your competition) giving you a HUGE advantage.

And here's where it gets interesting.

Because you've followed a proven formula you know your website will generate you lead and enquiries.

Then Magic Starts to Happen...

If you double the number of visitors you receive and then double your conversion rate (the number of sales you make). Which most photographers can do, you've just given yourself a 400% INCREASE IN SALES – 4x times as many bookings ...

How Many Leads are You Getting?

Old Way	New Way
1 – 2 Leads	28 - 30 Leads

Being at the top of the search engines makes doubling visitors easy for most photographers.

You'll probably find your visitors go up 5 – 10 times as much (especially if you currently rank below #5).

Plus, you have the option of appearing top for lots of other terms that you want people to find you under (so you get even more chances to get the customer).

It gets better for you.... Because

You can probably do far more because most photography websites I see (even the ones that look good) are poor in generating sales.

You could probably easily double or triple sales, by using a proven formula.

You see, it's pointless being top of Google if your website sucks.

Even if it does look good, it ultimately needs to generate you enquiries regularly) - and **do it**

WITHOUT you having to get involved....

What Most Photographers Do Wrong...

Most photographers or web designers use a template they see on the web because it looks good.

They then add their lovely photos, reviews, decide if they should include pricing or not and then add a bit about themselves and why they'll do a great job for you when you hire them.

It's the WRONG WAY to Do It – Here's Why

When we go looking for a product or service on the web from an unknown brand, we need to see certain things (and to make it better, see them in a certain order).

Think of it like a book...

You can have all the correct chapters, but in the wrong order not many people will use it and the outcome will be poor.

Put it in the correct order and you can have a blockbuster!

And psychologists have proved we need to see certain things

For example:

If you're looking to hire a local plumber first you start searching Google for plumber, you might then refine your search to 'plumber to fix shower' or 'Plumber + area name'

When you click on the link that interests you – here's what happens:

1. First the plumber must prove they can fix your problem. See a picture of a plumber and a shower and perhaps the words 'A Plumber for All Your Bathroom Problems' and you think great I'm in the right place.

2. Now you wonder if you can trust them? You've heard lots of scare stories; can you trust this plumber?

3. You scroll down their website and see a few reviews and testimonials from happy customers. This starts to put your mind at rest, next question…

4. Can they fix your shower?

5. Scroll down a bit further and now you see they have sections dedicated to fixing showers, another for toilets and another for taps.

Great you now click the link just for showers… knowing that this plumber can solve your problem and is trusted. You don't need to go elsewhere.

All the other plumbers don't stand a chance because this plumber just solved all your questions and you just made the enquiry.

Guess what – photography is not much different. Your potential customers still have the same questions

Questions your potential customers will be asking themselves …

- Will this photographer give me the best photos of my wedding, or of my baby, or my cute dog …?

- What did other customers make of you – are you as good as you say? Can I trust you?

- What can you do for me? I'm busy I don't want to jump through hoops just to see your prices, I just want answers to my questions without any 'sales talk'.

How Do You Solve That?

You'll be pleased to know there is a formula you can follow...

When it comes to putting your website together. That way you include everything you need -

AND in the correct order.

The result: You'll start to generate so many more enquiries and bookings.

Then when you start using Google ads and increase the number of people that know about you – that's when you start to get lots of bookings….

Because you appear at the top of Google.

You get more visitors and more opportunities to get the booking.

Your website is put together in such a way that it gets you the lead and enquiry

"Often you don't have to make big changes to your business to really increase your customers and revenue. It's simply a case of knowing what to do".

Following Up – Another Great Way to Get Customers

One of the **BIGGEST** changes you should make is how you follow up with prospects and customers. These are people

already connected with you, they already have some form of interest in you.

But how do your emails generate MORE customers?...

You probably know that it's important to keep in contact with all your contacts.

But do you?
If so, how do you do it?
A regular newsletter?
Perhaps a mailshot? All of which, if we're honest, isn't very effective.

You've done the hard work of getting them to know about you –

Why would you just let these potential customers just disappear to go and find a competitor?

Worse still, customers who have already ordered from you could be made into repeat customers with just a little work.

Now as you know I'm all into making things easy...

And over the past few years things have become much easier and you can now do some amazing things following up with customers and leads.

What's more – it's almost FREE to do.

And certainly, more effective...

Here's what I'm guessing happens now?

1 – You don't follow up with past customers or new leads?

2 – You group everyone together and send them all a 'nice' email!

3 – It's a hit and miss approach. Sometimes you follow up, sometimes you forget.

(If you're one step ahead you might just send your 'prospects' and 'customers' a separate email).

How often do you do it?

Is it regular?

Is it effective?

Do you ever forget?

In all honestly – that's an awful way to do it.

And that's why it's tough for you at the moment.

You spend all this time trying to get a prospect and when you do - you treat them like everyone else. You'll never stand out that way.

Here's what happens to these customers and prospects when they come to you...

1 – They love what they see and 'might' come back to you later (but then may well forget).

2 – They start to become interested in what you're offering but then get distracted by their mobile or Facebook etc and disappear.

3 – They are randomly searching when they come across you. They may like what they see, but then carry on searching and then can't remember you!

We've all been there and done something similar.

None of these situations are good for you – every time you are losing potential customers!

What should be happening is this...

1 – They come across you and love what they see. They enter their email address and now you have the ability to follow up anytime you want – even if they do get distracted and leave and then forget about you.

2 – They are interested in you, but don't enter their email. However, that's okay as well, because you have the Facebook Pixel installed and can still follow up with these people who already love your work.

Either way you stay in contact and then have every chance the customer will come back to you and hopefully order.

How much more effective is that?

This really does work.

This way you can take someone who was already impressed and convert them into an actual customer (or even a repeat customer).

First of all I highly recommend you sign up to **Active Campaign**

It's what I use and it's totally fantastic – I don't recommend anything else. In summary, it allows you to treat everyone differently!

The power you have at your fingertips is just amazing…. You can send everyone a different email depending on THEIR actions.

You don't want to treat everyone the same. Afterall, people are at different stages of the buying process.

1 - Some want to order now.

2 – Others are still deciding.

Plus, you don't want to send past customers all the same email. Some will have just purchased with you while others may not have purchased for over a year.

It makes complete sense to send them different emails.

For example, you can say a big 'Thank You' to the customer who has just completed an order with you. You can ensure that they are happy – and if they are pleased with your service, you can encourage them to leave you a review – which will help you even further.

Customers who haven't purchased in over a year you might want to offer some form of 'bonus' or 'special offer' to encourage them back. You certainly wouldn't want to offer that to someone who has just paid!

Follow up Examples

1 – **Baby Photographer** – "I was just going through my records and Wow, I can't believe your session was a whole year ago. I loved it and I hope you did too.

I'm guessing (automatically insert name) has grown a lot. If you fancy getting some updated photos over the next month, I have XYZ (insert offer) available…"

2 – **Wedding Photographer** "Congratulations on your first

anniversary. I was going through my portfolio yesterday and came across your photos. I enjoyed your amazing Wedding and it was a pleasure to photograph it.

I've got a few weddings coming up, but wondered if you'd like some follow up photos taken in a more casual relaxed manner. Past couples have really enjoyed these sessions and (insert offer).

Important – You can use this process for whatever type of photography you offer. It's a great way to capture extra business and can be fully automated (so you don't have to do a thing after the initial set up).

Imagine how useful that would be …..

A great way to bring in extra business just from simply sending an email.

Current Prospects…

Equally you do not want to offer discounts to someone who hasn't placed an order with you yet. Much more important to these people is finding out more about you and what service you can offer.

You need to demonstrate how you can provide a great service to them.

This shows the importance and effectiveness of [Active Campaign](). It allows you to give all your visitors a very unique experience depending on their actions.

FOR EXAMPLE

- You can separate out people who have or haven't read your email.
- You can separate people who visited your website and those who didn't.
- You can separate based on the day of the week.

In fact, you can separate your prospects and customers almost however you want.

You are then free to give these people EXACTLY what they want, and when they want it.

By offering a fully personalized service you are helping your customers in ways others can't.

FOR EXAMPLE

Let's say you photograph weddings or babies – You might want to send a prospect a link that shows them some of your previous work.

Then when you follow up you have two options on how you could separate these prospects (you have far more options available but I just want to demonstrate it here easily).

- A) **To those who opened and saw your portfolio you could say** "Thanks so much for checking out my portfolio. I just wanted to show you a few examples of what might work for you" etc etc etc.

- B) **To those people who DIDN'T see your email or portfolio** – There is little point in sending them the email above so you could say "I know you've probably been rushed off your feet, however I just wanted to give you a gentle reminder about taking a look at my portfolio. I think you'll get some great

> ideas etc etc etc you can check it out here…" and give them the link again.

See how you can give your prospects a unique experience and more importantly one that _works for them_.

This way you can connect with them and help them in ways you never could before. You can take each customer down their own process towards becoming a customer and in their own way.

You could never have done that before!

Another Bonus

With the average person getting 88 emails a day, your email to them can easily slip under the radar! No one wants that.

If they miss your email (unless they happen to remember you) - your chances of them becoming a customer have just reduced enormously. If the second email goes unnoticed you've almost lost the chance…

But this way, you can send a simple reminder – only to the people who missed your original email. Again, **you've just increased your chances of getting the booking.**

Start to see just how powerful this can be for you?

Now it may sound complicated. But it can actually be set up in less than 30 minutes.

All you need to do then is write your emails.

By the way – Did I mention This Is Automated?

Here's the best part (to me anyway) …

Once you've done the work once, that's it. It then just runs like clockwork 24/7 without forgetting and following up with everyone (never forgetting or making mistakes like you may do from time to time). It guarantees that everyone will be offered their own personalized journey.

Wouldn't you be wise to set this up just once and let it work for you?

How much time would that save you? I'm guessing hours and hours each and every month.

Use the AOMG Formula

Aggregation of Marginal Gains - small changes that can have big results.

Ever asked yourself - What is it that makes some photographers grow successful companies starting from scratch in a short amount of time - while others struggle day to day?

After talking with lots of owners and being in this industry for over 15 years I have realized the rainmakers understand 3 key principles.

Here's the truth for you

There are only three ways you can grow a business,

1 - Increase the number of customers

2 - Increase the average transaction value per customer

3 - Increase the number of transactions per customer

The truth is, if you can do all 3 things, you'll crush it. It will then be very easy and predictable to make six figures or more, and most definitely beat your competitors.

And I can honestly say that using the process of Aggregation of Marginal gains is the best way to achieve these results.

Why?

Because the results you get are proved to work – Tried, tested and proven to work. You can't get a better system and that's why the world's smartest companies are using this formula now.

Because it comes down to this and this is big ……

"He who can spend the most money to acquire a customer, wins."

Think about that for a moment. If you can afford to spend more money to acquire the customer than your competitor, you win. If you can't – you are open to competition that can win and put you out of business.

And it's these small changes that make all the difference.

Think about it – If you can afford to spend $5 to acquire your customers whilst your competitors can only afford $4, you win every time. You can start to dominate and crush it, and they can't do anything about it - that's what this is about, this is when it gets exciting for you…

The #1 result in the search engine can easily get twice as many people clicking on it than the company in #2. If you can afford to be #1, you get twice the opportunity to make the sale.

When you know you can grow your Photography Business through repeatable and profitable sales, you're going to have

more money. Then you can have the best cameras, lenses, lighting, backgrounds... the best marketing – you can get the best of the best because you can afford it -because you've got the proven system in place.

At the end of the day

There are really only 2 numbers that matter:

1 – How many visitors came to your website or saw your products.

2 – How many of those you converted into profitable customers.

If you're not making the income you want in your business, then let me ask you these 2 questions -

1 – Do you know how many people saw your offer in the last week?

2 – How many made you money - and what did you do about those who didn't?

You see in this game, it's easy to get distracted by all these activities and shiny objects. However, the reality is you need to focus on these 2 things.

What have you done over the past 7 days to really start growing your business?

The truth is, the successful photographers have a proven method for generating sales and know that with X dollars invested in business, what the results will be.

The rainmakers in photography have a predictable method for generating customers and they know their numbers

1 – Cost per visitor (how much does it cost you to get a visitor to your website).

2 – Cost per sale (How much does it cost you to get a lead and sale).

When you know those numbers - you have a proven, predictable system that is scalable. Then each month, it's a case of simply looking at your numbers and putting in place the system to get you to achieve them.

That all happens while the grinders and struggle bunnies are looking to pull a new rabbit out of the hat to get some new sales - trying a few new things they saw on a marketing forum or blog, hoping something they try will stick and work. They never change, they are not focusing on what works or on the important things.

In contrast, if you implement this system, you'll be like the rainmakers who are spending a predictable amount of money - investing in the strategies that they know produces results in terms of profitable sales and generating new customers every single month.

What does this system look like?

It's all about making tiny changes in your business that hardly anyone else notices. However, added together, it adds up to huge results.

For example, in Business:

Most photographers have never even heard of 'Aggregation of Marginal Gains'. You won't find books and essays on it. It seems to be a secret system that once discovered, businesses like to keep to themselves because of its' incredible power.

It's not just in business -

It was used in sport to devastating consequences... In fact, it was so successful other teams 'thought they were cheating'. Why? Because no one could spot the changes.

How it started in 1 tiny change...

Years ago, British cycling was going nowhere! They hadn't had any real success despite money being poured into it and all their expertise. They had some of the world's best experts and yet they were failing. That is until they called in Dave Brailsford into Team Sky Cycling Team.

Then 'EVERYTHING' Changed.

His task was to help Team Sky win a Tour De France in 5 years, even though no British cyclist had ever won it!

However, his plan was to use the magic of 'Aggregation of Marginal Gains' to dominate the sport.

It worked and here's the secret how...

The 1% TINY Change (That Competitors Never Even Noticed) - Changed Everything & Allowed Him to WIN BIG Advantage Every time!

He simply looked for 1% improvements in every aspect of cycling, especially in places 'other experts' missed. Almost every country involved focused on only the bike and nutrition.

Dave went further - much further. He looked for weakness in assumptions and then tested it.

Every single thing the cyclists did was analyzed - they looked at how to improve everything by just 1%. Small changes that nobody even noticed.

What did they look for?

"What pillows gave them the best sleep? They then took those pillows to hotels. What massage gel was most effective. How to wash your hands correctly to minimize illness and not lose training days. He saw dust on the floor that undermined bike maintenance, so the floor was painted white to show up any impurities. They looked for improvements everywhere".

How hard do you think it was for competitors to spot these changes? Virtually impossible - and that's why they thought they were cheating - Why?

The Result? MASSIVE WINS...

1% improvements everywhere added up to HUGE wins. The results were simply spectacular!

"More Success Than Anyone Else"

Complete Domination...

Team Sky won the Tour De France in 2 years, the first ever British cyclists to do so. They - won it again the following year - an amazing achievement.

Then came the Olympic games, the most competitive 2 weeks of sport in the world.

Dave was signed up to the British Olympic Cycling team to use the Aggregation of Marginal Gains again....

This Time the Results Were BIGGER Still...

"They won 80% of ALL the gold medals in the 2012 Olympics - The biggest sporting success in history" - all by using this formula of Aggregation of Marginal Gains .

You got any idea how tough that is? - NO team has even dominated like that.

Complete domination. Yet on the outside, to their competitors, it looked like nothing had changed.

All because of tiny 1% changes - Don't you think you should start using this formula for your success?

More Examples

It's been implemented in health care - A Seattle hospital wanted to try and reduce mistakes (and the resulting law suits!).

By implementing Aggregation of Marginal Gains, they <u>reduced their liability healthcare premiums by 74%</u> and it is now considered one of the *safest hospitals in the world*.

Just by implementing 'Aggregation of Marginal Gains'

How Google Used It...

The smartest businesses also use. For example, Google carry out thousands of small data experiments every year looking for tiny improvements.

They found that just by changing the shade of the Google toolbar from a darker to lighter blue it increased click throughs.

This tiny change increased revenue dramatically... and did anyone notice?

How hard do you think it is for competitors to copy? Almost impossible

and That Is Perfect for You...!

What can you improve in your business?

What will give your customers better results?

How can you serve your customers better?

So, by using Aggregation of Marginal Gains you can get big increases in revenue that are so hard to spot and copy. This obviously gives you a huge advantage - the ideal solution.

You'll then have more money to enjoy, and / or can expand your business in other areas. You can get the best because you can afford it.

Start to enjoy the lifestyle you want...

Look at this example...

Standard 1% Conversion ($100 Order).

If you're selling a $100 session and have just 10 visitors a day. That means you get 1 booking every 10 days for $100.

That means you're struggling at $3,650 for the year.

Increase conversion rate to just 5% and double the number of visitors which should be achievable given what I've shared with you.

You're now making a sale a day at $100 and over the year that's $36,500

This is a HUGE difference for making small changes.

And that is based on small numbers.

If you've already got a business – imagine what your numbers can be.

Increase your wedding bookings (If you're already booked solid – double your prices...).

By the way - I've had sites that convert at 14%

That's why it's important to implement what I'm giving you here. It can truly transform your life and business.

So How Do You Get Customers to Pick You

The big money in photography is when you become the King of the Mountain

I've already said it - but your skill as a photographer is not as important as your skill in generating yourself customers. I'll demonstrate why in just a moment.

You see, when you know you can generate customers at will - everything just becomes much easier for you.

The Difference between a $500 and $5,000 Photographer?

There isn't much difference between someone charging $500 for a wedding to someone who charges $5,000. It's the same with other types of photography. You're there for the same time, doing roughly the same job.

It's just about your confidence to charge a higher fee - the difference in the quality of the photos is often small. It's certainly smaller than you think.

It's just the photographers who charge more - know they can get clients and therefore aren't afraid of charging more. They simply know people are going to pay it.

It's the same as car garages, sports coaches, health providers – not everyone is on a budget. You just need to know that when you change your marketing you can attract the higher paying clients.

Plus, the customers paying the higher price often value your work more because it's a premium – it's a wonderful win / win.

Think about it. Compare this to Works of Art - you'll get some amazing art for a few hundred dollars, while other artists are charging thousands.

Can you really tell the difference every time? You see, when there isn't much difference between a photographer charging $100 a session – compared to someone charging $200, $500 or $1000.

Those photographers charging more know they can get customers and therefore don't end up competing on price like everyone else.

Secondly, you then need a marketing system, a way to generate yourself those appointments.

Thirdly, you need a process to convert those prospects into clients.

That's it, 3 easy steps - If you only focus on those three things you have everything that you need to start making 6 figures a year just like some other photographers are doing now. Don't worry about the other stuff.

Your niche and offer

Why do you need to pick a niche? Why can't you do everything?

Well, specialists earn more money - They get more respect and they have more fun –

I want you to think about his – who do you think gets paid the most money? The small-town general lawyer or the big city employment lawyer specialist?

If you had a problem with your employer who would you prefer to work with? The generalist or the specialist

The generalist will sit in that small office every day and see as many people as possible with 30-minute sessions. They'll try and help as much as possible but because they are a generalist they have the dingy office and can't charge that much and their clients are ok but always worried about the cost which is why they went there in the first place – so it makes it hard to make a profit let alone raise prices.

Plus, the clients are always thinking they'd be better off with a specialist who probably knows far more and would probably give them better results. The employment lawyer specialist can charge far more because they specialize in this area - it's what they do. Clients see them as getting better results which is what they want.

The price isn't so important to the client. It is the results that are most important - and they are prepared to pay far more because they want the results.

Plus, specialists are seen as authorities - the experts, the celebrities in their field. They have much more respect than the generalist - and earn far more - probably 5 to 10 times as much, maybe more in some cases.

They work in a nicer environment; they tend to have better and happier clients. And because of this, they are also less stressed and can enjoy life more, especially with the larger profits which are always nice huh. Therefore being a specialist is important and more appealing to a customer – yeah.

My point here is that you need to be a specialist - you don't want to be a generalist.

If you offer all types of photography then you're going to struggle to get clients today because anyone who wants a wedding photographer simply goes to Google and types in Wedding photographer, and guess what...

Google prefers specialists, all the 'generalists' don't get displayed until the end – you get lost, no one visits your website – and you don't have the opportunity to make the sale –

No matter how good you are – people won't know you exist if Google or the other search engines don't show your website within the first few results – OK.

When someone picks a photographer, they are choosing you for a specific job. They might be wanting you to photograph their wedding, a new baby, family portraits, pets, fashion event etc. They have a specific reason for wanting a photographer.

People are always going to make their enquiries with the dedicated wedding photographer who Google displayed first if they want wedding photography – they are taking all the business – regardless of their skill.

Maybe it's not fair, but that is exactly what is happening. See how this work and why it's so important – by not focusing on something you are already missing out on a huge opportunity and I mean huge opportunity to increase the number of leads and bookings you get and simply to increase your business.

Maybe this is different to the past. But this is how it is and you need to adapt and change.

Even if you don't have much competition in your area at the moment and you do show up on page 1 – chances are a specialist will still rank above you and take the majority of the business if they enter your market.

Think about this - you stand a much better chance of getting the customer as well – simply by being the specialist – it's what your customers want and it's what Google wants.

Both can reward you very nicely indeed. Imagine getting 30 or 40 times the number of enquiries you currently get – all from people wanting the exact service you offer, so you're already the perfect fit for them.

You get the picture – It's really hard to compete against a specialist, because your marketing becomes more powerful, it's easier to do, conversations are more meaningful…. It's just an all-round win win.

Think about this -

NEW MUM PHOTO

It's not hard to convince a new mum to get their baby photographed by a baby photographer whereas they are far far less likely to select a generalist photographer.

Or get your dog photographed by the pet photographer or have your portrait taken by the specialist who produces amazing results every time.

If you're wanting to increase sales at your restaurant – who would you prefer to hire for your menu shoot, the local generalist or the dedicated food photographer –

- Who's going to give you the best results.
- Who do you think will give you the best chance of increasing your sales?
- Who do you think has the opportunity of charging more?

This stuff works ok – people want SPECIALISTS.

Remember this…

Not everyone is price sensitive either. Yes sure, some people are - but you probably don't want those customers anyway. Because quite frankly, they probably won't purchase your larger offers because they are already on a budget and often they cause more issues than higher paying customers. Please accept that there is no reason or need to be the cheapest.

And think about this - It's hard to be the best in your market at a range of things - however it is surprisingly easy to be the best in the market at something specific.

Example

If you're building a house, you would not get a brick layer to do all your wiring and plumbing – because they are specialist at brick laying – and yet so many photographers want to photograph everything.

However, when you narrow it down and you focus on one thing, it is surprising how quick you can get good at it and how big the market can be - especially with the right marketing. That's how you'll start to bring in customers regularly.

Does that sound good to you? Do you see why a specialist wins and why customers are happier, and you can produce better profits?

The big money in photography is when you become the king of the Mountain. You want to pick one thing and just focus on it. Simply stop being a generalist and re-create yourself as a Specialist.

You see how awesome this could be for you – you see the potential ……

The generalist photographer is no longer your competition and they do not stand a chance.

You've just positioned yourself out in front as the go to photographer in your market. Now, this is where it gets better as well - because you'll either have this market to yourself or just have a handful of competitors. This makes your marketing so much easier than before.

Just think about this – if you're a photographer and your specialism is weddings - and then there's another photographer who is a generalist ……

If a potential customer meets both of you - Who do you think they are going to choose?

They'll choose you - the Specialist every day of the week and not only that, they're going to be willing to pay you the Specialist more. Remember, not everyone is on a budget. It's the same reason why some cars are a few hundred dollars while others are a few hundred thousand.

This is how you can better attract those high paying clients

Now, let's define your mountain right now. I've explained why it's important, and here's where it becomes easier as well.

Let's say you want to be the #1 wedding photographer in your area. How do you do that? How do you start to dominate your local market?

Firstly, when you are a Specialist, it becomes much easier because you can design everything you do around that one message 'Wedding Photography' (or whatever niche you select). And again, this works if you're photographing babies, families, portraits, pets whatever – I just want to give you an example so you know exactly what to do here.

Anyone who is looking for a wedding photographer in your area will hopefully come across you. It's now so much easier to stand

out than when you're a generalist. By owning your niche, you can speak directly to what they want and desire.

For example, on your website rather than just saying "Mary Janes Photography", you can now say something specific like "Mary Janes Wedding Photography Capturing Your Wedding Day Memories" – you can communicate directly because you already know what they want you to do.

This means, if someone is searching for a wedding photographer in your area, they'll probably come across you first and you'll have one of the first chances to get the enquiry. If you impress them straight away, they might not even go anywhere else.

Now because you're focused only on weddings, you come across as the expert straight away, you've already set yourself above your competition.

However, when you combine that with your message and by that I mean the way you communicate with your customer and the offers you make them, you'll be almost unstoppable in your market - because customers will want to work with you, the expert.

Then it also makes it much easier to raise your prices, and this is how you start to win and generate yourself a flow of new customers.

Think about this...

If you're looking to run a marathon – who would you want to train you and get you in shape - the generalist who does a bit of this and that or the elite runner who has already completed loads of marathons and helped others to do so.

Who would you pay more to?

Do you trust the generalist gym owner to get you the same results as the specialist marathon runner – of course not.

So, when you're booking a photographer for your big day, or to photograph your baby etc, who do you want? You simply want the photographer who will give you the best results. You - as the wedding photographer have that 'instant expert status' and the ability to charge more.

See how powerful this is?

Right now, you can be right at the start of this super new way of marketing and getting clients and you can do all of this and still help your customers in ways other photographers can't. This means you will become the go-to person in your market.

Would you like it when customers start seeking you out and coming to you - instead of relying on referrals and reviews and just hoping the phone will ring.

This is how you do it now.

When these prospects come to your website how do you make that more powerful and effective? So, when you get the potential customer you stand a great chance of getting them to make an enquiry with you, or book you up.

Now most photographers probably only get one or two people contacting them for every hundred or so visitors they get which is shocking (although I'm guessing most photographers have no idea how many people visit - they most likely only know the number of emails or calls they receive). They are missing out on loads of potential opportunities.

How would you like to increase that number 4 or 5 times, perhaps far more? So now – not only do you get loads more visitors because you are found more easily, you also generate

yourself more enquiries. Which results in more chances to sell. This is the way to increase your business to that 6-figure mark, to reach your income goals predictably.

Let us use Baby Photography in this example…

If you are photographing babies, and you're marketing to new mums because you know they are the ones who book. You can target your message directly to her.

You can do this by helping her from the start - so there is no pressure and no sales tactics which makes it much easier and more pleasant everyone. As a new mum, she's wanting a few precious photos of her new baby. She wants a professional photographer who can help capture the magic and beauty of this very special time…

And that's all she knows –

She doesn't know what to look for in a portfolio or what type of photos she wants, or even how to dress the baby so they look their best. However, she does want a professional photographer to capture her baby's beauty and she is prepared to pay you to do it.

So, what does she do?

She goes to Google and types in baby photographer. She is then likely to feel over whelmed from all the photographers in her area all offering the same thing. Now imagine how delighted she'll feel when she finds you, a true professional photographer who specializes in taking baby photos.

Finally, someone who knows exactly what she is looking for. Already you have just elevated yourself in her mind. Not only that, you also help her straight away by giving her a guide on how to choose a professional photographer and what questions

to ask and this can be done automatically (which I'll show you later how to do).

That way there is no pressure on her - and she feels completely comfortable and yet it doesn't take any of your time either. Do you think that would be good? Do you think she'd find that useful?

You also help to inform her of the type of photos that will work best with new babies (e.g. which by the way is exactly what you offer) and how to dress the baby for a photoshoot and what to expect so she'll get the most amazing photos to treasure forever.

The result - she'll be delighted and want to show off and share with family and friends. By providing this awesome information up front that is of use to her and of cause slightly biased to you without being salesy – it's of massive help and helps to set you apart.

Now, not only has she found you - a professional dedicated baby photographer who totally understands what she wants. You've just provided her with a lot of useful information. The result is only one outcome, all the generalists don't stand much of a chance. They were all busy saying book now, see my special offers, look at my portfolio, - while you said hey, I can help you - take a look at this I think you'll find it really useful...

Even if there are any other dedicated baby photographers, you have set yourself apart. You have just helped her in ways they didn't. Who do you think she wants to work with now? Who has that helpful expert status? See how this works. You're the only one who she'll probably want, because you stood out and helped her. She sees you as the baby photographer expert who will give her the best results.

And think about this, you can't directly help people like this when you're a generalist. You can now see why it's so important that if you don't already have a niche, you really need to focus on one. Because it will help to make you so much more effective and the best bit, probably far more profitable as well which is what you want.

Therefore, the Specialist wins every time.

Here's the Process from Start to Finish

This is how to get 5, 10, 20 perhaps far more new photography customers coming into your business every month predictably. What I'm going to show you now is the exact method that you can use to get clients and it's what serious photographers are using (because it works so well).

Here is the process from start to finish -

- You start off with an ad either on Facebook or Google
- People click on the ad and they come to a web page.
- They then they opt in – by that I mean they enter their email address
- Then we deliver the awesome information – all of this is done automatically without you having to do any of it (after you've set it up just once in your initial setting up).

It works 24 / 7 – so there is no waiting around for them and you don't have to send emails – it's all automated for you. Then the exact information that you gave them (your message) helps them make an informed decision.

At the same time, it positions you as the expert in your field. Then, depending on how you work, customers can book you up straight away or schedule a consultation. That way it's easy, especially when there's no pressure, or sales calls to make. Most of it is done automatically.

So that is a quick overview of the process.

How does it work?

Well after they have seen your ad...

Step 2 is a landing page (Important - you don't want to take these people to the normal home page of your website).

A landing page is a webpage that asks people for their email address in exchange for some content. You can build your landing page within minutes - I'm not kidding, you can build your landing page within like 30 minutes and you don't need any tech skills. Later in the book I'll show you how, but you really don't need to know how to code or anything technical.

Here's a tip – you want to keep it as close as possible to your ad (try and use the same image and wording).

We could say "Capture those precious moments now with your new baby and create memories that last a lifetime" –

"Showcase these precious moments in your baby's life, capture their beauty and innocence in a beautiful sequence of photos to treasure forever".

Then show a few bullet points...

How to decide if you want lifestyle or cute – What photos will give you the best result.
How to choose the best baby photographer for you – and what questions to ask.
How to prepare for the session to give you the best results.

Enter your email address to get access -

See there's nothing fancy to it – it's just a really simply webpage. However, it works like magic, this thing is brilliant - and you need to be using it.

It's very quick, simple and easy to set up and once people come to this page. They enter their email address and they are given

the appropriate details straight away and automatically. Again, you don't have to do anything (which is great!).

Now the next step is to deliver the information you just promised - and this is where you can start to build the bond with the prospect and show them that you're different to all the others. And that you genuinely want to help and that you're the expert at what you do.

This is where it's great. You are now ready to also show them things like your portfolio – rather than forcing them to do it immediately like all the other photographers. Wait until you have established this connection and now you can show them literally anything else you want them to see or know about you). And again, this is done completely automatically.

And here's the truth – this process works and it is what starts to separate you from the other photographers in your market. All without taking up your time after you've set it up once (which is really quick and easy to do by the way).

And then at the end – you simply ask your prospects to reach out if they'd like to book or schedule a consultation. And this is easy, it's a wonderful way to get customers coming to you. Plus, this way every lead is followed up perfectly with the right information at the right time When you get this right it can effectively help to generate you so many more customers.

Where Do Most Photographers Go Wrong?

If you look at their website, you will notice that it tends to be all about them. They're busy trying to get you to order, or get you to look at their portfolio, showing people what they do and what they're about. It's all push and no pull.

In contrast, when you start to draw people in, it starts to make everything else so much easier.

There's a load of psychology behind this - but trust me it works. Once you've helped someone you have vastly increased your chances of making a booking.

Who would you rather photograph your baby – someone who looks like a generalist and says they can do everything, or the expert who has just helped you?

The photographer who positioned themselves as helpful and as an expert and who was able to show you the style of photos you want. You know the other photographers in your market come across as a bit desperate and not so experienced – they're pushy – people hate buying from people like that.

And you know you don't want price dependant customers – they tend to create more work without being able to afford your larger offerings which is really when you can start to increase profits.

This really is the way you start to attract people into your business, it's a process that works so well.

It makes it far more about the customer - rather than a photographer showing off their skills and that's what it's all about – attracting those customers using a method that is predictable and repeatable and that can be done largely automatically.

See how this could really help you -

When you start helping customers first, you'll come across as the true, honest professional. The expert. You will soon start to see customers come to you rather than the other way around. It's just so much easier this way, you'll love it. Now you've just seen how easy this can be when you make a few simple changes and right now you have this amazing opportunity.

Plus, by positioning yourself as the expert and delivering value you also create goodwill. Therefore, these people are far more likely to recommend you to others. And by the way, because these customers weren't price dependent, chances are they know other people like themselves. So, you'll probably find your referrals are also much better. Again, making everything better for you.

If you're already a professional photographer this could help transform your business and you could see your profits vastly increase and start to go to 6 figures and beyond.

If you're just starting, this is the way to bring in predictable customers on demand and make your first few thousand dollars every month.

Now let's make this even more awesome for you. Now you've attracted the customer and you've delivered your amazing content. Next we want these prospects to book you up easily - either for the photo session or the consultation, depending on how you work.

I recommend you use some custom scheduling software. That way your prospects can see your current availability and schedule a time with you right away or even book up their session without any communication.

The easier you make it for them, the better your results will be. In today's market, people don't want to be going back and forth via emails or having to call. People expect to do these things straight away. It provides an easier service to your customers and gives you more time (especially when you don't have to keep answering the phone or go back and forth via email).

So, once someone has seen your portfolio and wants to know more, they come to a consultation / booking page which allows them to book up a time with you straight away. They can select

the date and time and it will go into their calendar and it will go into your calendar.

And here's the thing - because these customers have chosen to speak with you, there is no pushy sales tactics, they already see you as the expert. That makes everything much easier. When this happens, you should then be converting about 1 in 3 of these people, perhaps more.

For example, if you're using Facebook and getting clicks for about 50 cents each, you should be finding that you can get new customers for about $45.

How would you like to pay $45 to acquire a $500 to $3000 customer? - and you can be generating customers just like this. That's how and why you get predictable results.

When you know you can generate clients at will and everything in your business runs like clockwork, your success starts to become guaranteed.

That's when you can raise your prices and enjoy better profits and enjoy the lifestyle that it can bring. You can then get the best cameras, the best lighting and all the other equipment you may desire.

There you have a good overview of the whole process -

- You need to pick a Niche and Specialize in it.
- Start using Paid Ads to attract the Right Prospects into your Business.
- Send them to a 'Landing Page' and acquire their Email Address.
- Follow up and 'Help' them.

Now I'll take you through how to successfully complete each step. However, first it's important to ensure your website is working for you.

Make Sure Your Website Is Working for You

Everyone knows that websites can give you a massive increase in the number of clients you get.

However, many photographers are left struggling because they don't understand the science of making themselves a high converting website. One that turns more visitors into products than you do at the moment.

Sadly, a lot of photographers buy their lovely camera and all the accessories they need, because that's what they are passionate about. They believe they need a top-quality camera. That may be true, but you'd be much wiser to focus on your marketing first. Once you have your first profitable clients by all means go and get the gear you want then.

Unfortunately, a lot of photographers get the great equipment and then totally neglect their marketing or do marketing in the cheapest way they can.

However, you know you need a Website - right? The fact is, most people (around 90%) will visit your website before deciding on whether to book you as a photographer.

Most photographers might either build the website themselves or get a friend to do it. You might even get a web designer to do it for you. However, unless you understand Website Conversions, chances are, you'll come away with a great looking site. BUT, unfortunately it won't convert as many prospects into customers as it should.

Just because a site 'looks nice' and shows your great work, doesn't mean to say it can't be made lots more effective. In fact, often making small changes can make a big difference.

Want proof?

Go to Google and search for '100 Conversion Optimization Case Studies - Kissmetrics Blog'. Click on the Kissmetrics blog and look at the results of 100 website tests. You'll see some of the small tests that produced over a 100% difference in results.

That's right – changing a few things on your website could give you twice as many leads as you are generating right now. Perhaps more.

That's like doubling your business straight away…

There is a science to putting your website together, just like there is an art to photography. Get it wrong and it will cost you sales. Get it right and you can be very, very successful.

Unfortunately, very few photographers understand this and they simply grab a template and make the site look good by adding their photos and what they do etc.... - or use the templates offered by various photography services. To me that is such a false economy.

Now, remember around 9 in 10 of your potential customers will check you out online before contacting you. That number should be quite frightening because unless people have had personal recommendations about you directly you can lose the customer. Not because of your photography but because of your website. People are unfortunately judging your skill as photographer on how well your website works.

Crazy? Don't believe me? Let me prove it to you…

Most of your customers unfortunately can't tell an average photographer from a great one. They simply don't have a lot to go on when they are choosing a photographer. Chances are they have never done it before (unless they come to you directly as a repeat customer).

Therefore, they start making assumptions based on your website and your marketing.

For example, although everyone says "Don't judge a book by its cover", the majority of people do... and to prove it -

Author Naura Hayden released a book called Astrological Love and it really didn't do that well. It struggled, only selling a few copies. That was tough because she knew she had a good book.

What did she do? She kept the book almost the same but gave it a new title and a new cover – nothing inside really changed. However, the results this time were outstanding. This time it became a New York Times best seller and went on to sell over 2 million copies.

Yet all that changed was the way it was presented. Think of the cover as your photography website and marketing.

Please don't get too attached to your website just because you spent hours on it, or you invested a lot of money in it. I haven't yet seen a photography website that can't be improved. Do you really want a 'nice' website over a successful photography business?

If you're struggling to get clients or know that you could be serving more clients, then I guarantee that fixing this one issue can transform your business. And it doesn't matter if your site looks great at the moment, almost all the photographers I work with have good looking sites.

It is not that they don't look good. Simply that they are just not as effective as they should be. Think of it like your home - you know when you give it a fresh coat of paint - it just looks even better than before right?

By the way, here's the thing I get from a lot of struggling photographers who just don't want to change - they say, oh I really like my site or I've just spent x amount of money doing it and I'm really happy with it.

Honestly, that's like one of your clients saying to you, they love your work, the photos are amazing, but they only want digital prints because they want to save a few dollars and get a dollar store to print them.

Even though they've got great photos, they are prepared to wreck it all by saving a few dollars to print it out on some cheap printer when you could have given them stunning works of art in frames, or albums – photos that they'd literally treasure forever.

It's just such a false economy and it's costing you clients.

Because as I said once, you have the process that delivers you clients - that effective showroom, you can run a few ads and deliver yourself a nice flow of new clients.

Even if you have tried running ads before and they have not been cost effective – with this entire process, ads can become hugely profitable for you. Plus, the good news is that it can save you an awful lot of work as well.

Now, when you've got an effective process and you're able to take prospects and convert them into your customer much easier than you ever have before, it saves you so much time and effort.

And here's the great thing, with the extra time you can simply enjoy doing other things. Because you can now use a fairly automated process of attracting yourself clients. One that might only take an hour or so each week to look over.

This saves you from having to spend ages writing blog posts, posting stuff to Instagram and Pinterest and just kind of hoping someone will get in contact with you. You'll now have a process in place whereby you can run a few ads to attract those perfect clients and you then turn some into booked clients. What would you rather do with all that extra time?

The first impression you give a prospect is so important. It's an old saying, but it's true - "You don't get a second chance to make a first impression" - especially on the web when it's so easy to hit the back button and keep searching.

Think about this. Imagine if you wanted to buy a new carpet and you walked into the showroom and the carpet on the floor was all tatty and worn. No matter what the salesperson said, you're unlikely to buy from them because the presentation was wrong.

It is so crucial to get this first step right. Even if you are the very best photographer in your area - if you approach people in the wrong way, give them the wrong impression of your business - your skill is worthless. You'll really struggle to get clients and that's a real shame.

But,

When you do this right - you can overcome any competition even if you're more expensive and not yet established.

Here's another example – If I asked you to move a load of boxes and gave you the choice of using either of these two trucks, almost certainly you picked the big 4x4.

Why? You assumed it would do the job better, since the one of the top looks like it needs work.

For all you know, the 4x4 might not even have an engine. You assumed it would be better because of its appearance. And that's what people are doing with your website right now. The one on top might be a real work horse and run like a dream....

People are comparing you to all the other photographers they see on the web. And they are then making a judgement about you based on your website. Simply because they don't have much else to go by.

Would you like to be using a proven website design?

One that has been specifically designed to take prospects who are looking for a photographer and that gently guides them down the path to making an enquiry.

It's so different from what everyone else is doing and yet it's so effective. You've just seen how small changes can lead to big results - this is how you can transform your business.

Whereas before you may be getting say 10 – 12 enquiries a month. By using this proven process, you could be generating that many enquiries in one week alone. Imagine what that would that feel like! Would having extra customers help you right now?

If you start to get too many enquiries - simply raise your prices.

And here's the thing - you should also start converting a lot of these prospects into booked clients because of another process that I'm also going share with you in a moment.

Honestly that's the #1 reason why you aren't getting more enquiries at the moment. Fix this 1 issue and it can totally transform your business - and I mean totally transform it.

Take Sara - she's a Wedding Photographer who set up her business a couple of years ago and went to a local web design firm to put it together for her. It looked great and she felt very happy. At the time she was simply doing photography part time to try and pay some health bills (although it has to be said, she was good at photography).

But for the first year she really struggled. She gave away virtually free sessions to get some reviews and build her portfolio and she worked for next to nothing.

But what she couldn't understand was that there was another photographer a few streets away who was also a Wedding Photographer. But this other Photographer was charging upwards of $2k for each wedding and she was booked almost every weekend.

So why couldn't she get those clients - her photos where great - she had testimonials - she had done what everyone told her to do. Her prices were lower and yet she was still failing, but why?

Well, it all changed accidently for her when 'this competitor' who she had got to know decided to relocate. Just before she moved, they were having a coffee and Sara decided to ask her honestly what did she think she was doing wrong, why was she finding it so hard?

And the photographer simply said - look your, photos are easily as good as mine, and you do have a real talent but what's letting you down is your marketing.

For one she said - your prices are too cheap so you can't even afford to advertise. Whereas I can get clients simply by running ads, you have to rely on word of mouth or other really time-consuming methods that don't even work nearly as well.

However, she said - the real difference is when they come to me, I use a process to take them from a prospect and change them into a customer. Whereas you just rely on your website and wait for them to contact you.

And that was a real eye opener for Sara. Because all she could see was these ads and the website. She had no idea of the rest of the process. However, they discussed this, and do you know what? - Sara went away and implemented almost everything she was told.

In the next 12 months, she was able to raise her prices 400% and she went from having one wedding every 2 months to doing about 3 a month on average. She was ecstatic, and it all happened by spending half an hour over coffee.

And I want to show you this process yourself – because you can do this. It's really not hard when you follow a proven process. It allows you to overcome competitors and raise your prices. And the great thing is even if you're quite shy and don't like sales, this works for you because you start attracting clients who want to work with you.

And when they want to work with you, you really don't have to do any chasing or selling, it's just so much easier.

If you want these high paying clients as well, please change the way you bring clients in and attract them to your business.

And now it starts to get really good for you. It makes everything else much easier for you when you have a website that generates you clients. As that photographer said to Zara, you can raise your prices, but more importantly you can get clients where other photographers can't.

Now you know how important your website is. Want to fix it?

Here's the template I recommend you base any new design you put together on. Why? Because it takes your visitor down a very specific route into becoming a customer.

That's why I wanted to give you this free guide to walk you through the process.

You can download it as a PDF via

https://bit.ly/2kExs3H

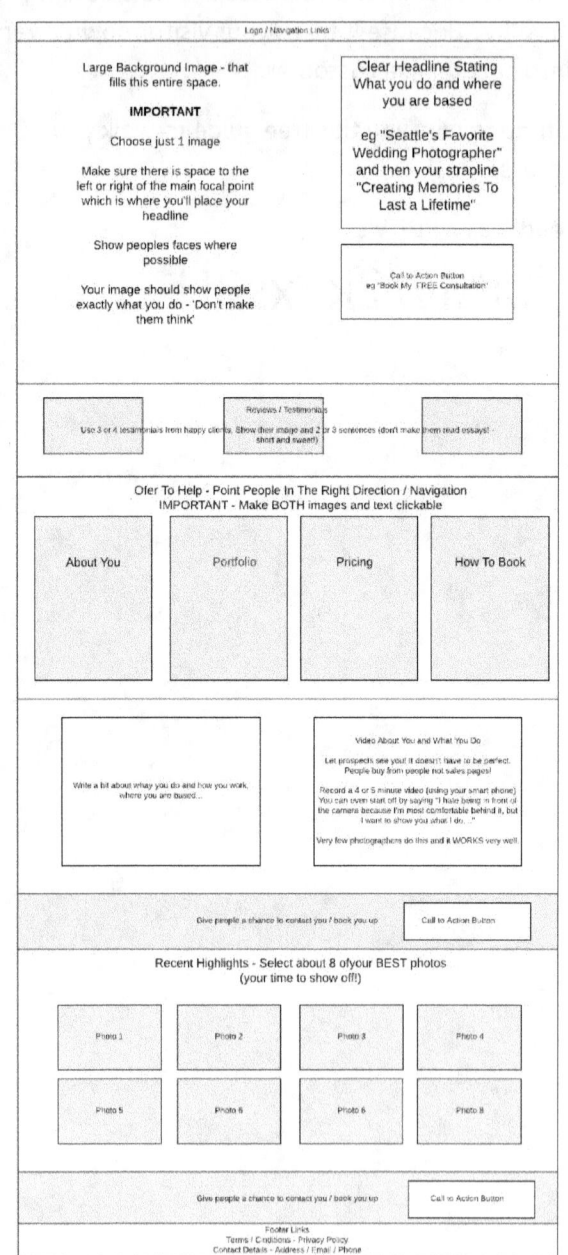

Why it works so well...

When a prospect comes to your website you have about 5 – 7 seconds in which to impress them and demonstrate you are the photographer for them.

Otherwise they will simply hit the back button, keep searching - and select another photographer!

The way you present your offer and images has a MASSIVE impact on your success.

Here's the order you should follow;

1. Logo and navigation links at the top. It's where people expect to see these elements.
2. You then need a large image demonstrating what it is you photograph. You should use people's faces where possible. Your visitors engage when they can see a person's face!

 Have an area at the side of the photo where you can insert your headline – telling people what you do "Seattle's Favorite Wedding Photographer" with a call to action.

 Now when someone lands on your site you have immediately answered their question in their head 'Can this person help me? Do they do what I want' After that their next thought is....
3. Can I trust this person? So just under your main image insert 3 or 4 great testimonials. Use an image and just 2 or 3 sentences (not the whole quote). Make it easy to scan.
4. Then offer to help – Point prospects in the right direction of what they might want to look at next.

5. If they don't select an option above, here's your first chance to engage with them. Tell them more about what you do, how you work, where you're based etc. If you can record a video that will help you massively.
6. Call to Action – Give prospects another chance to contact you. The easier you make this the more people will get in contact.
7. Show them your favourite photos. Choose your best 8 photos.
8. Another 'Call to Action'.
9. Your footer – This section should be on EVERY page and contain navigation links and your contact details.

It works because it takes prospects through a very particular sequence of events in the correct order. It's not just a random photography site that so many photographers use. It's based on a conversion process - so that you book more customers.

This works so well now because of the way people browse the web. Because so many of your visitors will visit your site using a mobile or tablet, scrolling has become the way of navigating. Having to click on small buttons at the top of your website can be a real pain on mobile devices. This in turn has affected user behaviour even when they visit on a desktop PC – the truth is users scroll more than they did before.

Above the Fold:

This is the section of your website that your visitor sees first (before they have to scroll) everything that appears on their screen in that first instance.

Here you need to develop a headline that speaks direct to what your audience wants. This is where it's so much easier if you have a niche because you can call these people out straight

away. That way your visitors knows straight away that you can help them with their specific requirements.

It's often reported that a visitor will decide about your site / business in under 7 seconds. You have less than 7 seconds to get across enough information to convince the visitor to stay.

Therefore, if they have to spend a few seconds even looking to see if you photograph what they want, you are making them work and it's creating a poor impression. The chances are they will hit the back button and move on to the next photographer.

So, it's important you come up with a strong headline that your visitor sees straight away. Your headline needs to demonstrate exactly what you do and how it will benefit them. Solve their problem and providing they can afford your services; you'll almost certainly have a customer.

E.g. If you're a sports photographer you could say "Sports Photography with Split Second Timing to Capture Those Awesome Moments". That way, straight away you highlight what you do and give the user a benefit of what you have to offer.

Pet photographer could say "Pet Photography Capturing the Inner Personality of Your Pet" - you get the idea.

The image that you use is also important. Showing people's faces work best. Make sure that if someone sees this image without anything else it's 100% clear what you do. You don't want big group shots if you're doing Wedding Photography. Just a picture of the bride and groom.

If you use a side on photo, have the person face your headline. If the person is looking in a particular direction make sure that's where your headline is. Your prospect will naturally look at the

face on the photo and follow where that persons eyes go. Therefore, you want them to land on your headline.

Social Proof:

When a prospect lands on your website you show them what type of photography you do, solving their #1 question straight away. Your prospect then starts to think…'oh great a wedding photographer, I wonder if they are any good'.

Now here's your opportunity to show off (just a little bit) - you want to feature 'social proof'. I don't mean links to your Facebook page. You want to demonstrate you are trusted and good at what you do.

So many photographers have 'their testimonial page' because they know they should have testimonials. However, that isn't that effective for you. You want to demonstrate straight away that people love your work.

If you've won awards now is the time to mention them. You want to take 3 or 4 of your best testimonials and feature them straight under your main image and headline.

That way the prospects says, 'oh good a wedding photographer - are they any good?' They scroll down and you answer their next question straight away and they think 'wow that's great, this person seems good'.

Keep these testimonials brief. One or two paragraphs (with one or two sentences each) and include the person's image to make it more believable. People are still wary of fake testimonials. Video reviews if you have them are best.

Guiding your audience:

Now you have answered the two most important questions in your prospects mind -

- Does this photographer do what I want?
- Can I trust them?

It then becomes more of a personal choice for the prospect. So, they will want to see more about you. Others will want to check out your prices to ensure they can afford you. Others will want to look at your portfolio.

You want to choose the 3 – 5 places to direct your visitor. Make it super clear what they are clicking and don't forget to make the image clickable (not just the button). You'd be amazed at how many people click on images. Don't make them work harder than they need to.

I would suggest links here to:

- About me
- Portfolio
- Packages
- Booking / Consultation

Make it easy and clear for your prospect to discover the information they want next.

Each of these sections should be divided up from the section above and below so visually it's easy to see.

Your Offer:

You now want to let your prospect to know a little more about what you do and what you offer. Since people are in different situations, it's a good idea to write a few paragraphs and include a video. Videos are super powerful – remember that not

everyone can watch them straight away. They might be browsing at work when they shouldn't!

Write something specific on what you do. Make sure you write it about them and what you can do for them. Where possible use 'you' instead of 'I' and try and include a benefit.

E.g. Instead of, "I've been a photographer for 15 years", you could try "with 15 years' experience, you'll receive those years of experience so you'll get photos that you'll treasure…."

Videos – They are super powerful and not enough photographers make use of them.

Remember you are trying to stand out from all the other photographers in your area. Your customers at this stage probably don't know you from the next photographer they stumble across.

What better way to start to set yourself apart and build your credibility than by using a video? Prospects can get to see you and hear you and that starts to build trust.

Just use your smartphone, it doesn't have to be fancy.

Please don't just produce a video showing your portfolio set to music. It does nothing to help the prospect. If they want to see your photos, they can go to your portfolio page.

Best of all - Is a video of you at work. That way your customers can see you working and start to see what they'll receive when they book you up. You can simply record a voice over to accompany the video explaining what you do and how you work.

Alternatively, you could simply record a piece to camera about what you offer. Try and make it engaging, rather than like a

sales presentation. Show your personality. People do business with people they like.

If you really hate being in front of the camera, you could show some of your portfolio and simply record a voice over to go with it. Again, explain what you do. Here you could talk about the story behind some of the photos you are showing.

To record vocals, you can get a great piece of free software from 'Audacity' (just search Google). To edit your videos, I suggest 'Camtasia' - you can get a 30-day trial with them.

If you want some help editing or get a professional to produce the video for you, you can outsource the work (often cheaper than you think) on sites like Upwork.com and Fiverr.com.

Calls to Action:

You'll notice that there are a few 'Call to Actions' throughout the page. By 'call to action' we are talking about what you want the customer to do next - e.g. book you up, schedule a consultation etc…

Again, make it easy for them. You want these buttons to stand out. Often the bigger and more contrasting they are, the better the results you'll get. Too often photographers choose buttons that look nice and blend in with the style of your site.

They might look good; but your conversions will almost certainly be lower. You'd be amazed at what a difference having a large contrasting button can make. Try it - don't make it hard for your prospect to take the next step. Every extra bit of work they have to do reduces your conversions.

Your work:

Here's the bit many photographers love. You now get to pick some of your favourite images. Don't get too carried away here.

Simply select 6 – 12 of your favourite photos that show exactly what you do. Then have another Call to Action below them.

For example, if you're a baby photographer, don't include an image of a family or a pet. You want these photos 100% focused on what you offer – your speciality.

Some photography websites I see go on and on. They seem to want to show every single photo they have ever taken without any Calls to Action. After a while, a prospect will just get bored.

Keep their action focused on what step you want them to take next.

Don't make these two big mistakes -

- Please don't use a 'free website' host for your business
- Please don't use a free email address e.g. Hotmail / Yahoo etc

It just makes your business look cheap and unprofessional. You can get hosting for about $5 a month and you can use your domain name from your email address (if you don't know how, simply ask your webhost or Google it). Personally, I love Google Business Mail and it's only about $5 a month.

Remember you are asking people for a few hundred or possibly thousands of dollars. They are comparing you to lots of other photographers. By using 'free tools' you are giving a low cost / slightly untrusting image of yourself. Already you've just made it harder for yourself to get the customer.

Also, today it's worth getting an SSL certificate installed. You can get SSL certificates for a few dollars and it changes your domain from http://website.com to https://website.com Adding that 'https' gives people that extra layer of trust in your business (and you want every advantage you can get). Some hosts will

install it for you. If not, you can get someone to do it for you fairly cheaply via Upwork.com or other outsourcing sites.

Follow this guide to creating yourself a very effective homepage. If I could get photographers to fix one element of their marketing this would be it. Without a good homepage, you'll really struggle to get a successful business.

99% of your prospects will see this first. If you lose them here, you won't get them back easily.

It's worth the investment to get this done professionally. It might cost you a few hundred dollars or a few thousand – chances are you would have paid that for your camera.

Make sure your website is working for you and helping you to get customers. It's truly one of the most vital pieces of your marketing to get right. When you do it right, our website can completely transform your business.

Special Pages to Attract Even More Customers

As well as your homepage you need to create what is often called a 'Landing Page'. This is simply the webpage that your prospect sees first - hence 'the landing page'. I mentioned it earlier in the book and is useful to send people to your Landing Page directly from ads.

If a prospect finds you naturally by searching on Google (e.g. they go to Google and type in 'fashion photographer in New York' and click on your listing) almost certainly they'll arrive at your main website homepage. You don't really have that much control on where Google takes that person.

However, when you run paid ads you have total control on what the person sees first and that's why I love paid ads. Because you can tailor everything to the user experience and give them exactly what they want.

Here's the secret – you want to create 'special landing pages' just for visitors who come to you via your ads on Facebook or Google.

In fact, you can have more than one Landing Page depending on what you are offering.

For example, if you are a portrait photographer you might design one set of ads that targets 'high school seniors' and another set for 'CEO's. Clearly you would want to give a different image to each audience to make it as relevant as possible.

In the natural search you couldn't make this distinction. However, with paid ads you can. In this example you would

create two pages. The first would have a headline relevant to high school seniors and their parents with images all of high school seniors, you want it 100% focused on this market. The next would feature messaging relevant to business leaders and photos of business leaders so as soon as they see it, it's a 100% fit for what they want. No distractions, you position yourself as the expert for them.

By making two separate pages, each becomes much more effective and highly targeted. The more specifically you can talk to your prospect the better the results you'll get. CEO's want a different outcome to high school seniors. You need to think clearly about what result your prospect wants.

This can work offline for you as well...

Top TIP - You could produce leaflets that have offer x on and send them to yourwebsite.com/offerX and another set of leaflets could send them to yourwebsite.com/offerY – that way you can see if offer x or y resulted in more traffic. You then know what offer is working best for you.

So, what's the point of a 'Landing Page'?

Apart from being able to tailor your message directly to that particular prospect, you really want to get them to engage with you.

It's very hard to get someone who has never heard of you before to book you up for a photography session and spend hundreds (sometimes thousands) of dollars with you on their first visit. I'm not saying it doesn't happen, but it's very, very rare. Research has showed that customers often need multiple points of contact before they will consider booking with you.

On your Landing Page, you want your prospect to take a 'very small step' down that process. It's much easier to get a person

to take lots of small steps than it is one huge step. Their barrier to resistance is much lower.

If you wanted to run 5k and had never run before and I said to you let's go and run 5k together you'd probably tell me where to go. However, if I said to you 'come on let's just run to the other side of the street' you're much more likely to give it a go. Once you have made that first commitment it's easier to get the second.

Interesting read - http://www.directcreative.com/influence-and-persuasion-the-rule-of-consistency.html (or Google 'Influence and Persuasion: The Rule of Consistency - Direct Creative)

So, what do you want them to do? What 'small step' should your prospect take in becoming a customer?

Ideally you want to collect their email address. Why? Because it allows you to effectively follow up with them almost for free when you want to. This whole 'follow up' process is covered fully in another chapter. Right now, your goal is to capture their email address.

How do you put your Landing Page together?

The good news is that you can largely base it on your homepage with just a few changes. For example, if you are targeting particular people make sure your photos and wording all match that market (as previously mentioned).

But at the top of your page, instead of having your 'Call to Action' to make a booking you want them to enter their email address.

The easiest way to do this is use an email sign up form. A box on your website that allows customers to enter their email address.

Sadly, however I would expect less than 1% of people to enter their email – Why? Because they know entering their email address will probably result them in them receiving emails from you - and at this stage they are cautious.

So how can you greatly increase the chances of your visitors giving you their email address?

Simply put, you want to bribe them!

Yes - you want to give them an offer presented in such a way that they think the benefits outweigh the chances of receiving a load of junk emails.

You want to make them an offer they can't refuse. The better the offer, the better your chance of capturing their email address and then of making a sale. Without capturing their email, making the sale later will be much harder.

Think of it this way. If your offer said, "Enter your email address and I'll give you 30 high quality photos of you and your family 100% free" how many people will join? Probably most, since your offer is so good.

Compare that to a form that says, "Enter your email address here". How many would sign up?

Now clearly, you don't want to giveaway your photos - so here's exactly what you should do. Come up with an offer that is hard for your customers to say no to. Personally, I'd try and stay away from discounts. You don't really want your customers to come to expect discounts (after all it hurts your profits as well).

What I suggest you do is create a useful free report that you can giveaway and deliver automatically (explained later) something like "The 12 best locations to get married in XXXX" or "How To Avoid a Wedding Photographer Disaster By Following These 7 Rules" (people are more likely to take action to avoid pain than

they are to gain e.g. it's better to say 'How to save $5' than it is to say 'How to make $5) or "3 Reasons Why Using a Professional Food Photographer Increases Sales"

You get the idea – Come up with a report that would be useful to your ideal prospect. It doesn't have to be long, around 10 pages is fine.

In the report, you need to demonstrate value - help and guide your prospect as much as possible. Whilst you know a lot about your niche, chances are your prospect has never hired a photographer in your area before.

For example, if you're a baby photographer think of what questions people have asked you in the past and make sure you answer them in your guide. How do I dress my baby, what outfits look best, can I feed my baby, change a nappy etc …? The more you are able to help the better.

This guide can start to position you as the expert.

Of course, in the guide you want to show off with some of your favourite photos and you can direct people to see your portfolio on your website.

Plus, make it easy for them to take the next step, phone you, email you, book you for a consultation. Tell them clearly what they need to do next and what to expect.

For example, if you offer a consultation say something like 'Sit down and enjoy a coffee and we can discuss what type of photos work best, any ideas you have - there's no sales talk - it's just an informal chat etc...." Include testimonials for added trust.

However, please don't bury it away at the end of the report in small print. Make it clear, make it stand out. It's too important, you don't want people to miss it.

Big Tip: To give an extra 'Wow' factor to your report, you want to get a great cover designed for it so prospects can see something visually. It's far more effective than just a headline and a place to enter your email address.

To get a great cover go to Fiverr.com and look for 'ebook covers' or post a project on an outsourcing website like Upwork.com. It makes your whole report look more professional.

If you are doing high value work like weddings or each sale you get is in the high hundreds or above, you might want to consider making your report slightly longer and getting it professionally printed. You could probably get each booklet printed for a dollar or two. Then, if you actually send it to your prospect it gives an even better impression. Makes you really stand out.

Next step...

Now that you have your report designed, you need to get people to enter their email address.

First you need to give your report a great headline (if you want ideas Google 'headline copywriting').

Secondly, come up with 3 or 4 bullet points to let your visitor know what they'll get inside. Each bullet point should only be 1 or 2 sentences. You want it to inspire curiosity, tempt them to find out more.

E.g. rather than saying "I'll show you what to wear for the best photos", you could say "Use these 5 surprising clothing tips that will make your photos truly stand out".

Then, under the book cover, you want to place a button that says something like "Get My Free Copy". When a prospect clicks on that link, a box appears that asks for your email.

If you ask just for their email address your conversions will be higher than if you ask for name and email. However, generally the more fields you ask for the better the prospect. However, personally, I would just ask for their email.

If you want to send them the guide, use the small steps principle. Don't ask for all their details on that form. Just ask for their email address. When they click the button, they are sent to another page of your choice. This would then be the ideal page to say that you'd like to send them a free printed copy and ask for their address details. Since they have already taken that first small step, your conversions should be higher than if you asked for all the information up front.

You may need to get a web designer to do this for you or you could try some of the software below

- Clickfunnels.com – What I use and recommend
- leadpages.net
- tenminutefunnels.com
- builderall.com
- cloud-press.net
- https://instapage.com

It is worth getting your landing page right.

You want to aim for at least 20% of the people who see this page to enter their email address. Ideally it will be above 30%. Less than 20%, you will need to come up with another offer or write better copy to get the visitor to enter their email address.

Tip: The wording that you use on your advert either in Facebook or Google use in your headline if you can. If you can't, try and make it a close as possible. It helps with continuity. People see your ad and are tempted by what you write. That copy should also be on your Landing Page - so they know they are in the right place.

Added Tip: The image that you use on your ad (in the case of Facebook) - use the same image on your landing page.

IMPORTANT – Every Landing Page must have a link to your 'terms of service', privacy policy' and a 'contact' page. If you don't, you are at risk of your ad account being shut down (often without anyway of reopening it).

I'm not a lawyer and this is NOT legal advice any way. If you don't have a 'terms of service' page you can Google 'terms of service generator' on Google and find one that suits your requirements (and do the same for your privacy policy).

Another Big Tip: After entering their email address you need to direct your prospect to another page on your website. Many photographers simply choose their homepage - and this is a mistake.

Why? Because right now, you have one of the first opportunities to engage with your prospect and to make them a small offer.

You want to send them to a 'thank you' page that you create. It will say something like "Thank you for registering for XXXX, It will be sent to you automatically in 5 minutes after this video has finished".

Just below that, you want to put a video that you recorded (you can use just text if you want, but video will give you the best result) that makes them a small offer. Again, trying to get them to take that next small step with you.

For example, if you're a wedding photographer and you offer a consultation. You could record a video that says something like -

"Thank you so much for requesting your free guide, I'll send it to you automatically at the end of this video. However, I just

wanted to take 5 minutes to say hi, tell you a little about what I do and give you an amazing offer....."

At the end of the video, you want to make a small offer saying something like - "I know choosing a wedding photographer is hard, there is a lot of choice. So, I'd like to make you a small offer whereby you'll get some amazing photos of you and partner that you'll treasure forever, and I can demonstrate the quality of my work.

I promise there won't be any sales talk, but for just $$ you'll get XXXX photos which would normally cost $$$ so you're getting an amazing deal... I'll be honest with you I can afford to do this because I know from experience most couples are blown away by the photos and some go on to book me up, but again there is no sales talk. I'll just give you some great photos and leave the choice with you".

You get the idea – then just tell them how to take the next step. Hopefully you'll use an online booking form.

If you don't offer consultations, you could say 'I know how hard it can be to choose a 'your niche' photographer and that sometimes life just gets in the way and you don't get around to it. However, if you book me or make an enquiry with me in the next 2 days then I'll also include XYZ free for you....."

Again, you get the idea, you just want to provide an incentive for your prospect to take the next step.

This is just another opportunity you get to make the sale or take the booking that you wouldn't have had otherwise – if you were using the 'old' method of just hoping someone will contact you.

Let Me Show You How Important This Is...

Let me give you an example:

Say you get 5,000 people to see your business. Here's what can happen:

- A poorly designed website that has the email sign up form lower down your webpage gets only 5 email addresses.
- A great offer with a form higher up on the page gets 65 email addresses.
- A great offer using a landing page gets 1000+ email addresses.

Remember these are highly qualified visitors who ALL expressed an interest in your product.

What list do you think has the best chance of making more sales and getting more customers?

Which list would you like to own?

Follow-Up Marketing

Now following-up with your prospects is one of the most important things you can do in your business. If you really want to increase your sales, improving your follow-up marketing can be a game changer.

The average photographer does very little in the way of following-up with prospects; although they probably know they should be doing far more.

What do you currently do?

Perhaps you don't do anything because you weren't able to acquire any details about your prospect (you are left only hoping they come back).

If you did manage to get their email address, what type of emails do you send them? Do you always remember? Do you simply add them to your newsletter? How often do you follow up? Once, twice and then figure they aren't interested?

Because you are now using a Landing Page and have also put together an offer that people want, you should be collecting far more emails from people who are highly interested in your business. The perfect combination.

Here's where it starts to get exciting for you…

You want to be using a special tool called an 'Autoresponder' to take emails to the next level.

Autoresponders are a fantastic method that allow you to easily keep in touch with your customers and potential customers automatically without you having to do anything. Set up correctly, auto responders are one of my favourite methods of generating new sales and getting repeat orders.

A lot of photographers try mailshots to try and get business. But doing mailshots can get quite expensive, especially if you want to send thousands.

Not only do you need to pay for the artwork to get set up, you've got the printing and distribution costs. Plus, what if there is a mistake?

What about a customer who contacts you and asks for your details? Wouldn't you like to be able to send them everything immediately? But then also automatically follow-up a few days later asking if they received it ok and if they had any questions?

Just a simple follow-up can turn a browser into a buyer. If they don't buy then, what about contacting them a week or so later with an offer?

Well using Autoresponders allows you to set all this up in just a few simple steps.

Firstly, it's important you understand what Autoresponders are.

They are basically a piece of software that allows you to reply automatically to customers who enquire by email.

Simply put, if someone emails, you can set your email to send a reply automatically to them depending on what words are used in the email they sent or what email address they used.

Example - A customer emails yourname@companyname.com – You could have an autoresponder that replies to any email it receives at yourname@companyname.com to reply with full details of what you offer. You can include any links you want, perhaps send an attachment.

Now, this email would be sent straight away. It doesn't matter if it's 2am on Sunday morning. The customer would receive an immediate reply.

Or you could simply have an email that replies to everything that says - 'thank you for your email and we'll be in contact ASAP....'

You can also set the Autoresponder to spot certain words in the customers email and then send a set reply. So, if the customer writes "…. prices…." in their email, you can have it set so once it sees the word 'prices', it automatically replies with your email giving them all the details they need on your prices and packages.

Just a note that if you use lots of keywords and different Autoresponder messages, it will often take the first keyword it spots in the email and use that as the reply.

These are fairly easy to set up and since all email accounts are different, I would suggest you contact your email host (generally whoever you host your website through) and there will be some instructions in their FAQ pages. Just search for 'Auto Responders'

Want to see where the real 'magic' happens?

There are some software services on the web that let you use Autoresponders in far more creative ways and really make them very, very powerful. They are such a good way to communicate directly with your prospects and go far beyond a simple automatic reply to an email.

Imagine being able to write a series of emails all at once telling your customers all about your photography business.

You could get them to visit your portfolio page, tell them how to book you up, explain how a consultation works.

Then, if after that sequence of emails, the customer hasn't booked you can offer them a special voucher that ONLY goes to

those customers (not those who booked from your original emails) and you can automatically keep following up.

Don't be afraid...

Especially with this set of 'pre-customers', don't be afraid of over emailing. Now I don't mean send 2 emails a day for a month. But there is nothing wrong in sending 5 or 6 emails within a 2-week period. Because often that is when the prospect is most interested in your service. Just make sure you deliver value.

After that, slow the sequence down to perhaps just one email per week.

If a potential customer contacts you, chances are they are looking to book either then or within a few days or at the very least are a strong possible customer in the future.

So, make sure you follow-up with these potential customers and get your name in front of them for when they are ready to book. You want to have 5 or 6 emails ready to go straight away.

After that time and they still haven't purchased, follow up with them once a week. You want to keep your name in their mind for when they do need a photographer.

Now you DON'T want to keep emailing them the same email every week. It's boring and they'll either delete it or unsubscribe and you won't have any more chances to make that sale.

Generally, your follow up emails should be a combination of useful information and offers. I usually go for two content followed by one promo.

Here's what to include in those Autoresponder emails:

Not sure what to write about?

Ask your customers what they want to know more about?

Think about what sort of questions your customers ask you. That's exactly the type of information you want to start writing down in an email. Even if it's already on your website, they may not have seen it, may have forgotten it.

Think of each question you get and write a useful detailed response. These can form part of your Autoresponders.

Not only do they help your customers, they also cut down on your work. Rather than having to email each customer individually, it can now be done automatically. It makes you more efficient and gives your customers a better experience (and of crucial importance, no prospect is forgotten because it is an automatic process).

You want to make your email something people want to read. It should be designed to position you as the expert in your field, the 'go to' photographer.

Include GREAT CONTENT that people want to read, share and tell their friends about.

Your Autoresponder sequence might look like this

Day 1 - Deliver your free report (sent automatically after they signed up).

Day 2 - Follow up to ensure they received your free report and ask if they have any questions.

Day 3 - Here's some questions a lot of customers ask me (provide value).

Day 4 – No email today.

Day 5 - Here's how to;

Just make the subject line interesting enough that people want to open your email. Then give them enough good content to make them actually read the email.

Do it once!

Now here's the magic: ALL these 'pre-customer' emails need to be written only once. Although this may seem like a lot of preparation work now, remember that ALL these 'pre-customer' emails need to be written only once. Yes, that's right. You do the work once. Then load it into the software and for even years to come, it can automatically follow up your customers - leaving you free to do the more fun things in your business.

And another way to use autoresponders is for your current customers. When a customer places an order, you can take them off your 'pre-customers' and transfer them across to your 'customers' list.

After all, you don't really want 'customers' receiving certain offers that you are using just to tempt that first booking, do you?

So, once they have become a customer you will want to send a different kind of follow up Email.

Here's Your First Customer Follow Up Email

Your first email should be along the lines of 'thank you for your booking'.

- Here's what you'll need to bring, this is what to expect, here's how to find us, any questions....

Make it friendly and welcoming. Treat them as a valued customer, not just a booking. Making your customer feel special

and creating the right first impression is vital - so spend time making sure this is right.

You could even get a copywriter on Elance.com to write or polish up your emails to help them sell better. Writing high converting emails is a talent in itself.

Your Second Customer Email

Then after the photo session, have a follow up email that says something along the lines of;

- "Thank you so much for coming to see us, it was great to see you and we really hope you enjoyed it….

As you know we are a new family business who really care about our customers and want to try and let others know about our service. We would really appreciate it if you could leave a positive review at (review websites) any questions please get in contact…."

3rd Email

You can always follow up (automatically using your autoresponders of course) a week later saying something like:

- "Thank you for coming to see us... I've been so busy I haven't had chance to check if you were able to leave us a positive review. If you were, thank you so much. If not, is there any chance you could do it today please at…. It would really help at lot."

Getting those important customer reviews will be very important in gaining new business so you want to do everything

possible to encourage it. Be sure to read the chapters on 'customer reviews'.

Then you'll want to keep in contact every 1 - 3 weeks or so. Again, use a mixture of content and offers. If you have great content, do it regularly. If you struggle for content only email once or twice a month. It's better your emails are read than simply binned or marked as spam!

These people are the easiest people you can sell to. You have already proved your service and they have trusted you. So, treat them as special customers and try and make offers they can't refuse.

You should also contact these customers and ask them to refer you to their friends. They are a great source of new leads.

Read the Facebook marketing chapter because your customers email address can also be used to great effect when you are advertising on Facebook. You can do some very clever stuff. Almost certainly none of your competitors know about this method.

I hope you start to see the power of these tips. When you fully understand and start to think of your own ideas for content and offers, you'll discover how amazing this can be.

Someone contacts you just once and you can keep in contact with that person for years -automatically offering your services. You could never do that using direct mail or Yellow Pages ads. This is really powerful.

Need extra business during quiet times?

Also imagine you normally have a quiet spell in the middle of August because everyone is away on holiday.

You can easily send out a newsletter to either your prospects or customers and come up with a great reason for doing a super offer…

- "Just to let you know that since everyone is away on holiday for the next couple of weeks, we have a few rare late availability sessions. So, I have decided to do our 'best offer of the year' if you book……" you get the idea.

You can use these to help get bookings for times when you are normally quiet. It's also useful to give a reason for your offer as it becomes more genuine.

In the example above, the customer can see why you are giving a discount. It's a quiet time of year so you want to fill some late availability. That way they won't expect discounts all the time, which is not what you want.

So, who do you use for your autoresponder?

There are loads of good solutions out there. But the company I have used for years is

ActiveCampaign.com

Now in all honesty, I don't know how they compare on cost. They are probably about average. But I have found them faultless.

Their service is great, and the software is easy to use - even for the novice. I personally would rather pay more for them and use a quality product.

For example, you can personalise each email - so you include your customer's name. It makes it far more personalised and there's a higher chance the email will be opened.

If you only want to send them an email on a Tuesday morning you can.

In your sequence of emails, you can say watch out for a special email from me in 5 days (and it can then automatically insert the date 5 days from then). You just need to think of some great ways to use it.

Follow This Guide and It Will Get You Leads for Your Photography Business

Let's Set Up Your First Ad

Use this guide right now to attract your perfect customers using Facebook. Put it into action and get yourself hot leads 😊

Warning – Do not use your personal page for your photography business.

Facebook are banning personal accounts where people are using it for their business. It's against their 'Terms of Service' and at some point, they will discover it (they are using artificial intelligence to do so). Don't take the risk and get your account banned / blocked – set up a Business Facebook Page straight away (and it's free to do it).

First – You need a business Facebook page for your photography (Free)

If you don't have one set it up now via
https://business.facebook.com
(You can follow Facebook's guide here -

https://www.facebook.com/business/learn/set-up-facebook-page/ if you need help)

Here's Your Detailed Guide on How You Get Hot Leads Now!

Don't follow Facebooks advice on creating ads – you will overspend.

Inside your Business Facebook Account

Go to your page – Then from the 3 bars in the top left, from the dropdown click 'Ads Manager'

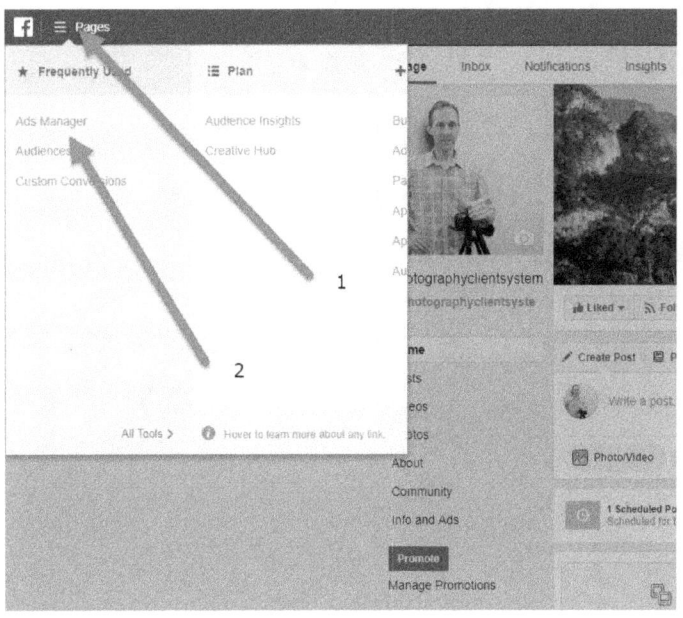

Click the green 'Create' button

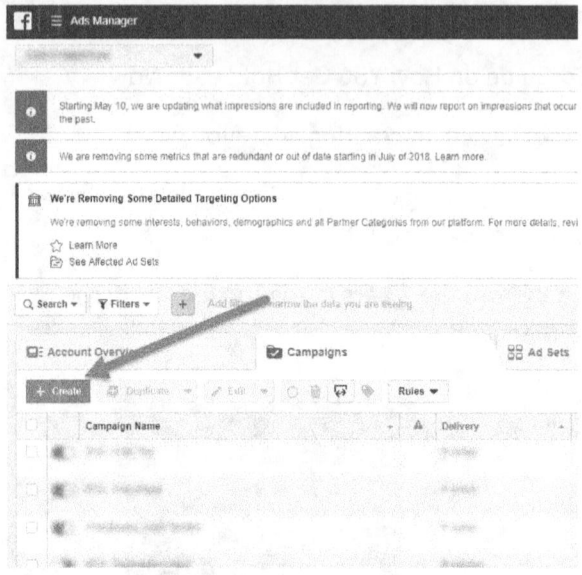

Click the 'Lead Generation' button

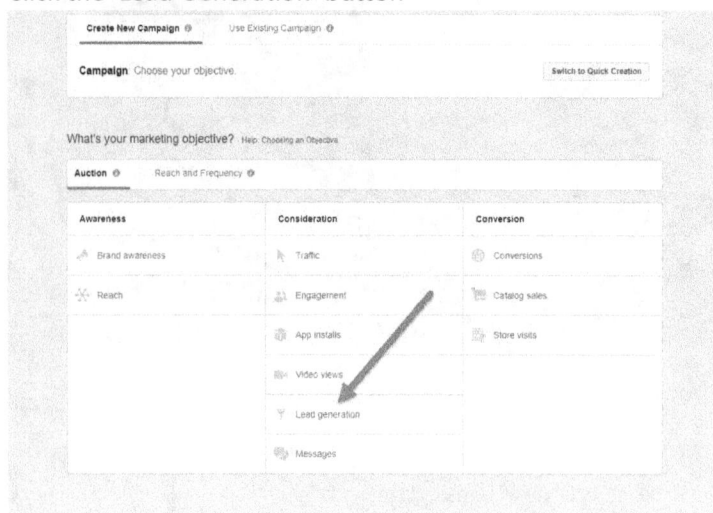

Give the campaign a name and click 'Continue'

Then read and if you agree approve Facebook's terms (If you don't approve you won't be able to run ads).

Then under the 'Audience' headline enter the location you want to show your ad to e.g. 'Seattle'

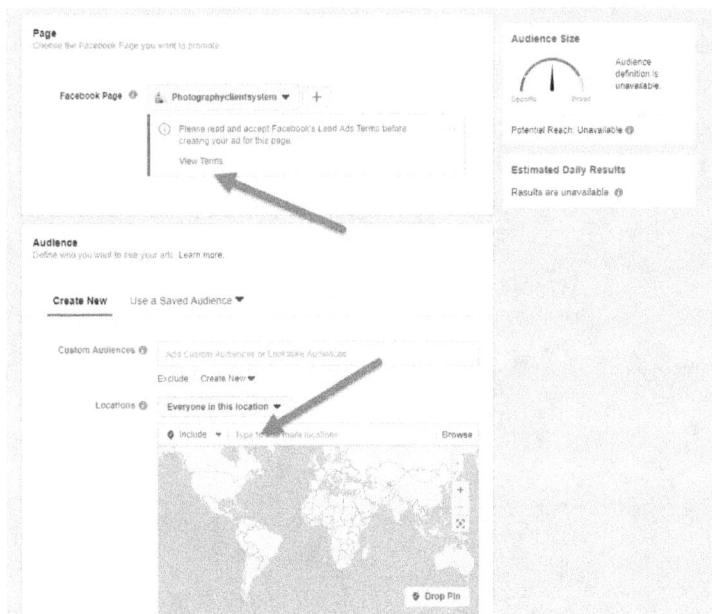

Then under 'Detailed Targeting' choose who you want to target your ad to e.g. 'engaged' people for Wedding Photographers or 'Newly Engaged'

In this example, it would give you a potential audience of 35,000 prospects – I think that might keep you busy for a while!

You can choose 'new parents' if you photograph babies. Or parents with children of certain ages. You can select pet owners. People interested in boudoir. You can find your audience here. You might need to get creative…

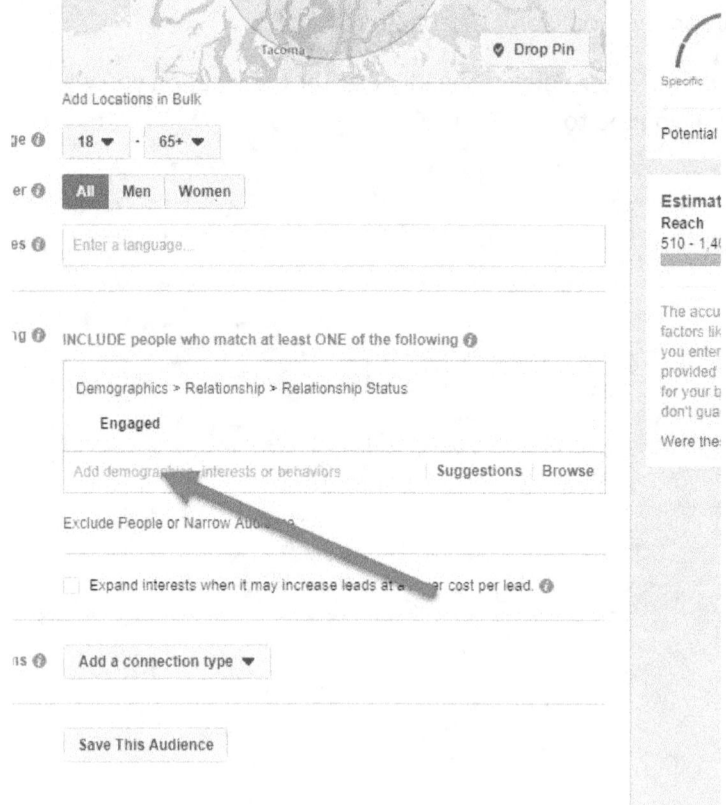

This is IMPORTANT – You MUST EDIT PLACEMENTS

Audience Network is not available for 'Lead Ads' but if you use other ad types it can be. <u>Always</u> make sure it is turned off! These clicks tend to be awful quality!

We only want Facebook and Instagram.

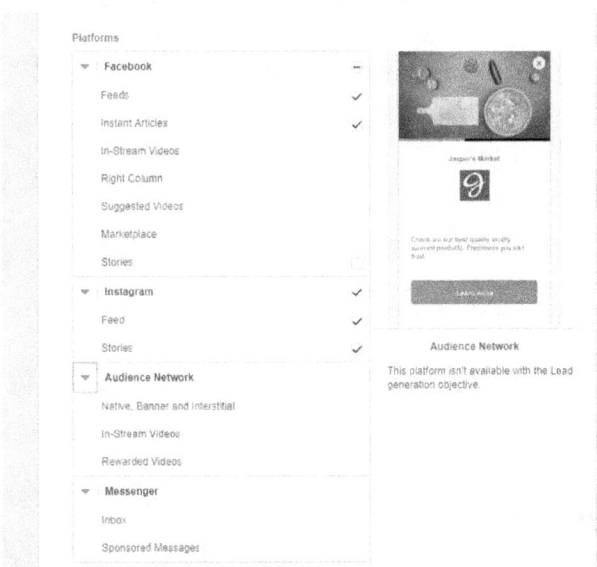

Then enter your daily budget and leave the other options as default (below) and Click 'Continue' in the bottom right corner

Then we create your ad 😊

You can upload your own images, or video... Make sure you use an image that shows exactly what you offer e.g. if you do Weddings – show a bride and groom (people and faces work well).

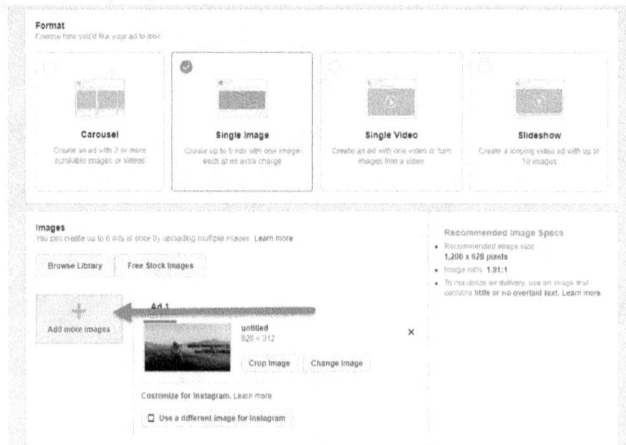

Next you write your ad – Decide exactly what you are offering.

You want to give something of value. REMEMBER these people are hot prospects who are giving you their contact details. People looking for a wedding photographer – parents wanting baby photos etc... see the text in the example below. Emojis 😊 can work well to capture the eye!

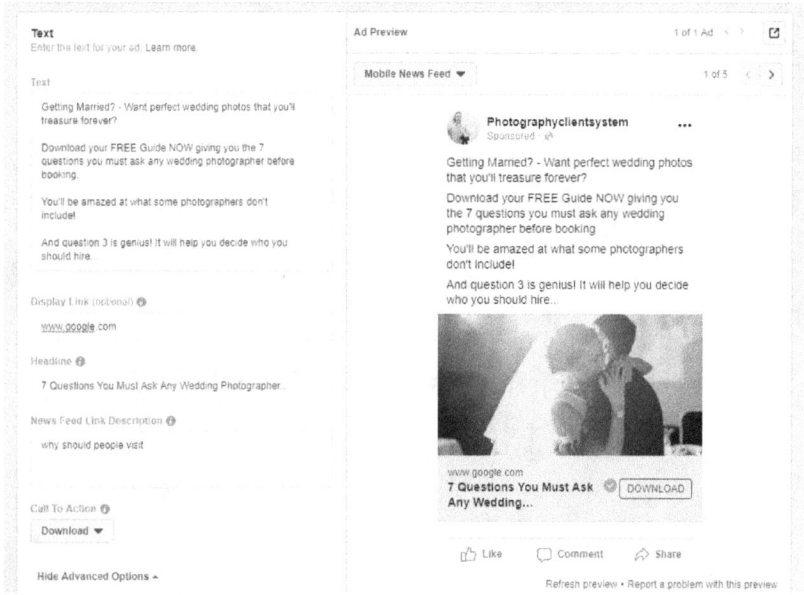

Next scroll down and click 'New Form' to generate your Lead Ad

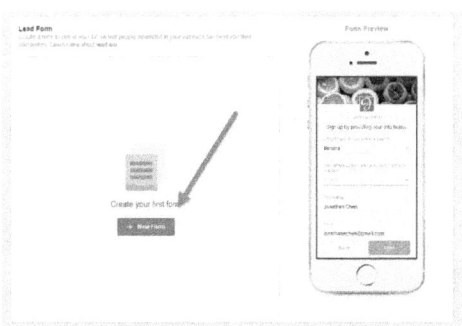

Under 'Form Type' leave the option set as 'More Volume' then click 'Intro'

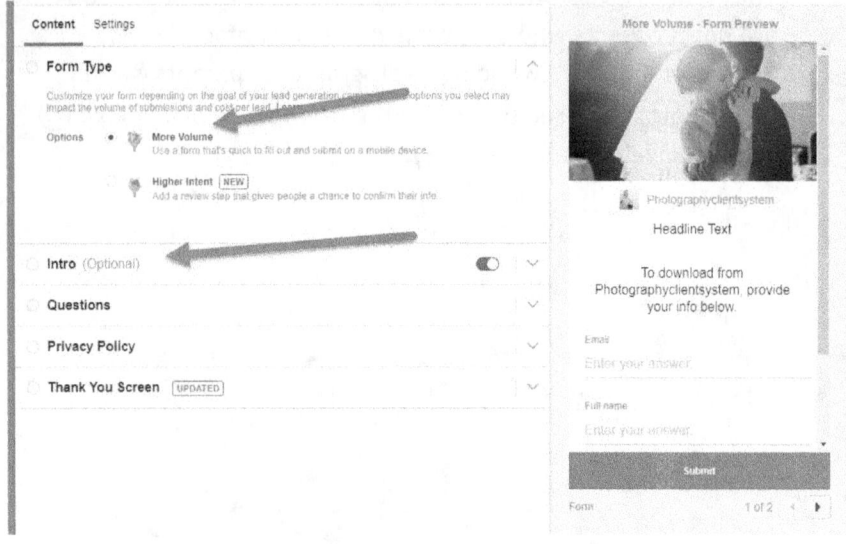

Enter a headline that restates your offer and in the paragraph form, just one or two sentences about it.

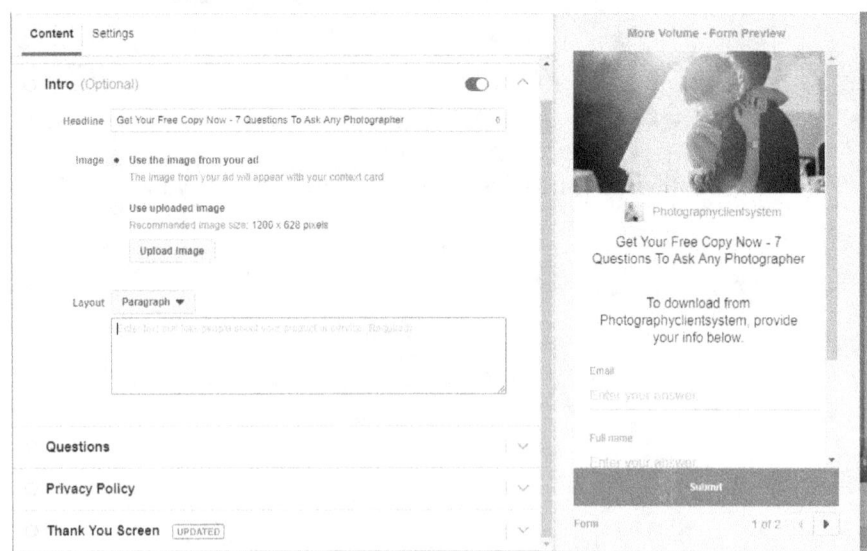

Under 'Questions' you can change the text that appears under the headline. Use something like "Please check the details below and I'll send you a copy right now :-)".

Under 'Show More Options' – click so that you can collect more information. Please note that the more details you collect here, the fewer people who will contact you. So, unless you are planning on calling or sending information to them, just stick with Name and Email for the lowest prices per lead.

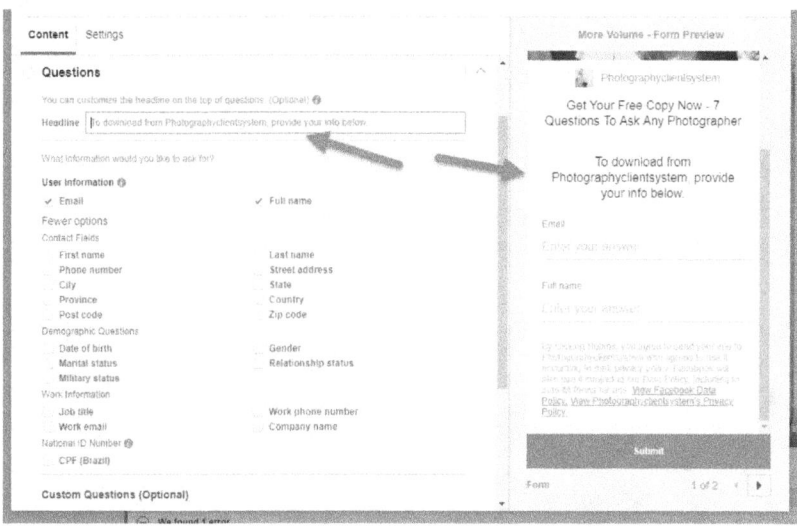

Then click 'Privacy Policy' and add the links to your privacy policy. (If you don't have one – and you should, search Google for Privacy Policy Template or Generator and find one that suits you).

Finally click the 'Thank you Screen' tab.

And let people know how to get the information you just promised. Normally if you created a pdf report you can upload to Dropbox and simply use that link in the website address and

label the button to 'Download Now'.

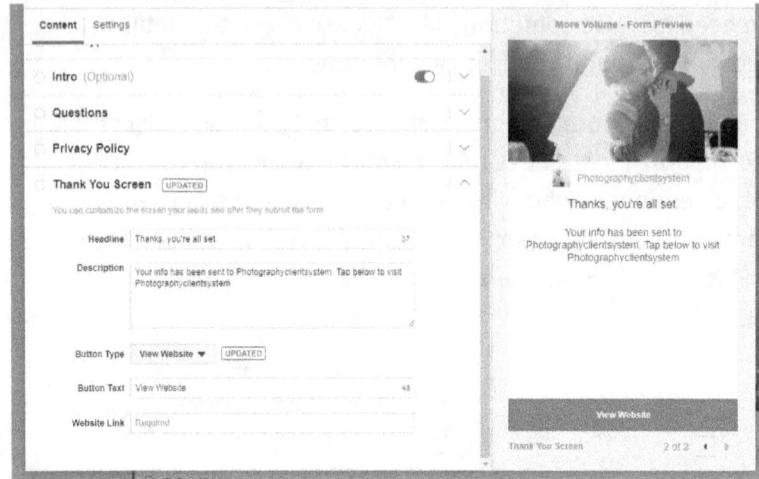

To complete your ad Click 'Finish' in the top right -

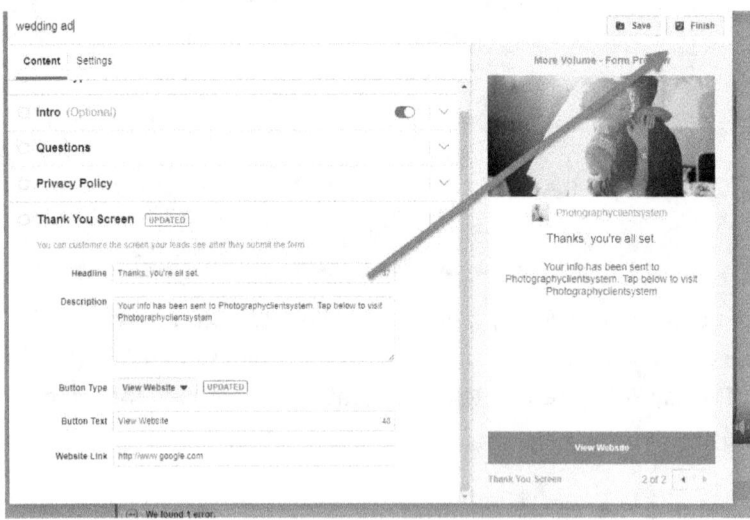

The last step is to click the green 'Confirm' button -

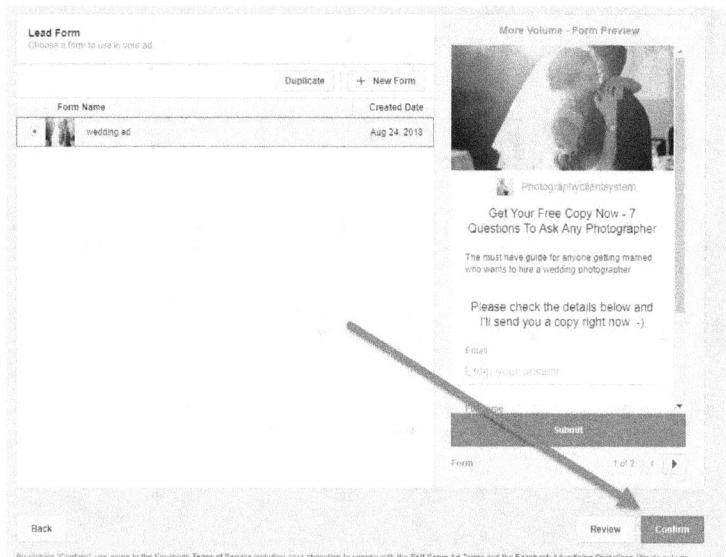

Now you have your first ad. Let it run for a few days. Facebook will start to learn your audience so your cost per lead can vary over the first few days (more than when the ad is established).

Photographers Who Give Away Free Stuff - Get More High Value Bookings and Have an Easier Time Attracting Customers...

How can giving away 'free stuff' help you get more high value customers? First, it's important to know -

1. **You are not giving away your work** - In fact it will help you get more customers (and better high paying customers) 😊
2. You only have to do this once 💚
3. It separates you apart from your competitors 💰

How Does It work?

Before I explain what you need to do, it's important you understand why this works so well. When your perfect prospect goes looking for a photographer, they are going to see a page of results on Google that look like this...

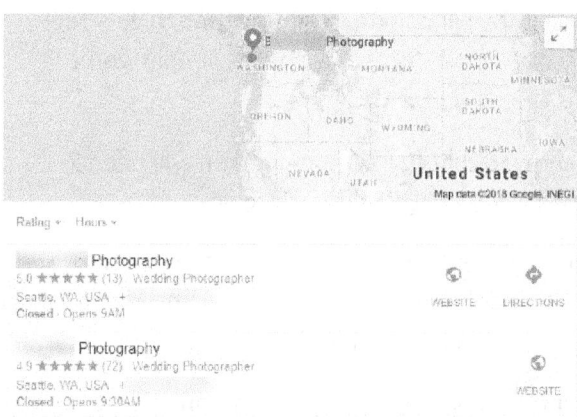

All these photographers are saying roughly the same thing...

"I'm a great photographer" (or words to that effect) pick me!

Almost every search result promises you amazing photos.

It doesn't matter what market you're in - weddings, babies, portraits, pets, commercial etc... everyone says the same.

Then it gets worse - When you visit their website, they immediately tell you how much they love photography:

They tell you *why* they'll do a great job!

They *show you* their favorite photos...

They'll tell you to get in contact straight away...

THAT'S WRONG

In honesty it's desperate – Here's Why?

Because unless these photographers get the prospect to contact them straight away - They've most certainly lost a potential customer!

A tiny number of visitors will bookmark you, although very few will remember to come back – Most prospects, simply won't contact you again! Not Good ☹

Yet research has showed that the average person will need 7 points of contact with you <u>BEFORE</u> contacting you!

So, if you're trying to get your potential prospect to contact you on their first visit - you are fighting a losing battle and losing potential sales ☹ You don't want that...

This is just like a photographer going up to someone in the street, showing them their photos and asking them to book straight away. It has a very low success rate!

☺ Here's What You Should Do... ☺

You want to write a 'Free Guide' like this (It doesn't have to be complicated) providing value to your ideal customer.

(If you want it to make it look awesome you can find a designer on Upwork.com or Fiverr.com to design / lay it out for you. Just give them the wording and the photos to use).

For example, if you're a wedding photographer you could write

- The Ultimate Guide To the 12 Best Places to Get Married in Your Location

- The 7 Must Ask Questions You Should Ask ANY Wedding Photographer Before Booking

If you photograph Babies, Families Pets etc…

- The Ultimate Guide to Taking Awesome 'Baby' Photos with Your Smartphone

(Some photographers get scared when they see that title because they fear it will put them out of a job. It couldn't be further from the truth – I'll explain why in a moment)

Commercial photographers – show why using a professional photographer increases sales.

You need to make the guide valuable to your prospect.

Something they will want to read. If you're using the 12 locations idea research it, include address details, costs, how many people the venue caters for, why it's a great location etc – Then tell them about your photography services **and make them an offer**… start to encourage the first repeat visit.

If you're using the 'Better photos with your smartphone' give as much value as you can. Give people techniques to use, let them know about facing into the sun etc…

If you're a studio photographer - show people how to take better photos in the park.

If you photograph outside - Give advice how to photograph kids at home! If you do both give advice on how to take better photos all-round. **Make it useful** for the reader so they can _take action_ on what you give them 😊.

THEN – in your guide you transition as to why hiring a professional photographer will give them amazing results.

Educate them as to what happens. Show them how you edit photos to make them look truly amazing.

💚 "You're creating works of art that they'll treasure and remember forever"

Show them the Difference Using a Professional Makes

From This to This ...>

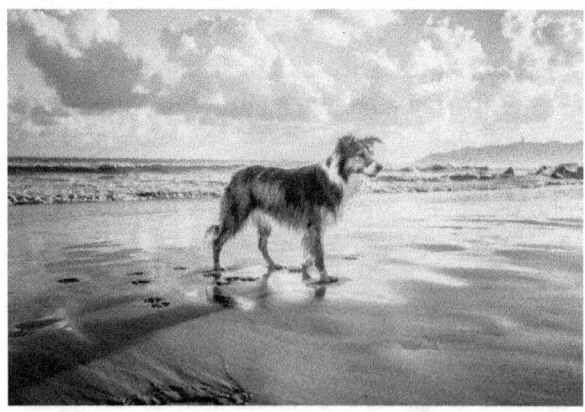

"Another great idea is to use room mock-up images" Which you can get from stock photo sites.

Let them imagine what having an amazing piece of art would look like in their home 💝

Then in your guide

- You can include your favorite portfolio images.
- Include customer testimonials if you have them.
- Make an offer / Call to Action (What you want the prospect to do next).
- Include your contact details.

After You've Put Together Your Guide… What Next?

Then you simply want to offer it to your visitors / prospects in exchange for their email address (you can also collect name and phone numbers details if you want).

Now instead of being like all the other photographers pushing hard to get people to act straight away – You can use attraction marketing and it's far easier…

"By providing value first"

Who would you rather work with? …….

Someone you have never heard of OR Someone who has just helped you?

Who do you think the prospect values more?

- Who would you prefer to work with?
- Who positioned themselves as a friendly / helpful expert?

You've separated yourself from the other photographers who are saying 'Look at me', 'Book me'...

You can focus on providing help and advice. BUT...

😊 It's Better Now...

Because most important of all, you can now follow up that prospect

And that is so important (because it helps you to reach that 7 points of contact).

You now have the prospects email address and possibly their phone number. Follow up over the next few days providing more help and advice...

- Tell them more about your service.
- Show them what they can expect when they work with you.
- Show them testimonials from previous customers.
- Include a 'Call to Action' in all your emails. Give them a reason to contact you.

Not everyone will contact you...

That's ok, you can also easily contact them again in a few weeks with more useful advice and help and / or make them another offer.

Plus, your ad on Google or Facebook will stand out now!

Whereas everyone else is saying "Wedding Photographer Seattle | Capturing Awesome Moments" etc...

You can say

"Free Guide To..." and answer their questions.

- As a prospect what's more valuable.
- What stands out more.
- What are you more likely to click on?

That all gives you MORE opportunities to get the customer

Your ad costs are likely to be lower per prospect (Google and Facebook both reward good ads). Some photographers can generate new enquiries for just cents.

It's a great method that very few photographers are using and yet it works well.

Important...

This whole process can be automated once you've set up once – giving you more free time while providing a better experience for your prospects.

Remember This....

You've now started to separate yourself away from your competition by providing value. In the same way you are reading this guide (and possibly read some of my others), you're getting free help and value.

- By doing this, you've seen that I know photography marketing and how to do it effectively, so you get results.
- You can see why the process makes sense and customers value it.
- And by using this process I can help you get more customers.

When you follow this process - You're positioning yourself as the expert.

At the same time, it allows you to attract MORE customers.

What's Next?

The Better Your Offer – The Better Your Results...

Wedding photographers should always offer a free consultation as the next stage of the booking process.

However, to take it to the next level, you could offer a free photoshoot and give them a free print. Here's why...

If you're going to invest 30 minutes to an hour in a consultation, then an extra 15 minutes can transform your results. By giving couples a lovely photo of themselves you invoke 'reciprocity' – Making it far more likely they will book you up. Please do it – it works 😊.

It also makes your ads far more effective. It's an all-round win/win.

A Quick & Easy Guide to Getting Your Photography Business Listed Near the Top of Google So You Attract More Customers Fast...

I say 'near the top' because the top spots are reserved for paid ads – and this is 100% FREE 😊.

One of the easiest and fastest ways to get more photography for your business is to get a good listing in Google. However, it can be tough to get well ranked. One way to get around this is through Google Maps. It is much easier to appear in Google Maps and it can be an effective as a source of new customers.

This guide will give you a quick overview of how to get inside the top 10 listings as quickly as possible - even the Top 3 💰.

Why do you want to be top 3? Go to Google and search your area for a photographer. Are you listed? If not, this is for you... Often Google only lists the 3 in its' display so ideally you want to be featured there!

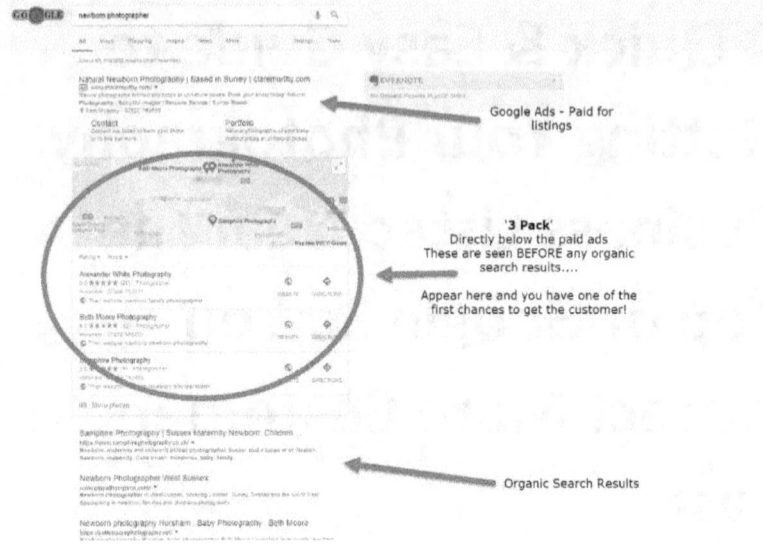

Step 1

First you need to create your Google Maps listing. It's straight forward. Just follow Google's instructions.

https://www.google.com/business/

Step 2 – Improve Your Listing

Once you have your listing it's important that you fill out ALL the information completely. If there's an option to enter some business details enter them.

For example, list your opening hours – simply put the hours you are happy to take calls!

Make sure you fill out ALL the information!

If you see a 'pencil' mark – that means you can edit that information.

Make sure the information you enter is accurate

And is consistent with what you have elsewhere on the web!

WHY?

Google searches your site and all over the web for information about your site and it wants DETAILS TO MATCH UP!

If it doesn't match - Google doesn't know what to trust and that makes it harder for your site to get listed.

Make sure phone numbers, addresses etc are all consistent.

There is a more detailed guide here - https://moz.com/learn/seo/local-citations

Want to make sure your details are correct try this https://moz.com/local/search

Google Maps – Categories

Make sure you are listed in the correct category.

The first one should be your main category – what you photograph most. But you can add more than one category – but only if it applies to you. Don't go getting listed as a 'studio' if you don't have a studio. Google is smart and devalues incorrect listings. It wants a trusted database.

Quick Tip – It will probably happen naturally but it's a good idea to use these page categories in your websites page titles. For example, your page could be called "Seattle Aerial Photographer: Up High Photos"

https://support.google.com/business/answer/7249669?hl=en-GB

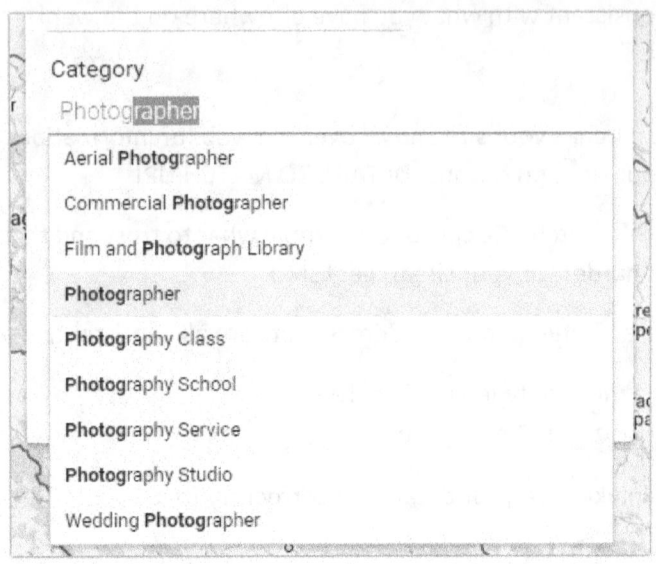

Write a Great Description…

You'll have the opportunity to enter a description of your business. You are allowed 750 characters (BUT only about 250 characters are displayed).

You are best to write 2 or 3 very short compelling sentences. You want to use your most important keywords e.g. 'pet photographer' and if possible where you are based.

Here's a link to learn more - https://www.brightlocal.com/2018/05/02/optimize-google-my-business-description/

For example - "Aerial photographer based in Seattle taking breathing photos of your home or business. Award winning photographer, fully licensed who will…."

"Wedding Photographer based in Seattle who will create

memories that last a lifetime. 10 years' experience, 5 Star reviews let me capture the magic of your special day"

Try and make your listing stand out, try writing it from your customers perspective.

New - Services

Google recently added a services section.

Make sure you fill it out for an added advantage over those who haven't noticed it yet.

It's a great opportunity to tell people about what you do. Ensure your description is enticing and makes people want to know more.

What's Better?

- 1hr photography session including hair and make-up with 5 edited prints...

Or...

- "Come and enjoy a 1hr photography session. First, our hair and make-up artists will make you shine (many customers love this part as much as the main session). You'll walk out looking and feeling amazing. Then the shoot begins. I'll guide you through every step, so you'll get 5 perfect photos. Not only that, I'll edit them, so they truly sparkle and capture your inner beauty".

What's more compelling for the customer?

What would you click on?

Your descriptions are important. Use them to your advantage.

Final Steps

Within a few days, go searching for your business and hopefully you'll appear in Google Maps.

If you're listed, but not yet in the Top 3 what should you do you do next...

Reviews are important – after you've done a session if the customer is happy suggest to them that leaving a review would help. Many people don't understand how important reviews are and gently asking them is fine and a great way to boost your profile.

Add your best photos to your listing.

Now Access your FREE Videos

https://photographyclientsystem.com/50kbook

If you need help you can contact me directly

alan@photographyclientsystem.com

Important - Also just like in your business, reviews help a lot. Please would you take 30 seconds and leave me a review on Amazon. I'd be very grateful, thank you 😊

www.ingramcontent.com/pod-product-compliance
Lightning Source LLC
Chambersburg PA
CBHW070646220526
45466CB00001B/315